A Garland Series

The
Art Experience
in
Late Nineteenth-Century
America

Twenty-six of the
most important titles from the period
reprinted in thirty-three volumes
including over 4,500 illustrations

edited with an introduction by

H. Barbara Weinberg
Queens College

Garland Publishing, Inc., New York & London

1977

Library of Congress Cataloging in Publication Data

Clark, William J 1840-1889.
 Great American sculptures.

 (The Art experience in late nineteenth-century
America)
 Reprint of the 1878 ed. published by Gebbie & Barrie,
Philadelphia; with new introd.
 1. Sculpture, American. 2. Sculpture, Modern--
19th century--United States. 3. Sculptors--United
States. I. Title. II. Series.
NB210.C58 1976 730'.973 75-28869
ISBN 0-8240-2229-7

154533

Printed in the United States of America

Introduction

H. Barbara Weinberg

The Civil War represents a significant juncture in the development of American art and taste. The native roots that had nourished American art in the preceding half century atrophied as a result of the economic, political, and philosophical upheaval that accompanied the War. Thus, a search for new sources of inspiration to replace the earlier moralistic and naturalistic interest in landscape and rural genre began. This search was stimulated by the industrialists and financiers who had enjoyed perhaps the only genuine victory of the War. Desiring a cultural expression of their new power, they developed a taste for European art and enthusiastically imported it to provide a stamp of sophistication and respectability for themselves.

American artists were undoubtedly affected by the growth of new national values and by collectors' predilections for European art in the decades after the Civil War. With few exceptions, these artists increasingly explored foreign precedents and sought European training to develop an art related to traditional and contemporary European art and to American needs. Their retreat from realism was accompanied by a heightened interest in ideal art, expressing more of the conceptual than of the purely perceptual. They examined new subjects in figure painting: the nude, genteel urban society, religion, and mythology. They turned to flowers and bric-a-brac in still life and took a meditative and subjective approach to landscape. They experimented with new media, including

watercolor, etching, and pastel, and met the challenge of a new type of commission with a variety of mural painting styles and techniques. Sculpture of the period reflects the same eclectic idealism that prevailed in painting.

Having acquired artistic training abroad, particularly in Munich and Paris, American painters and sculptors returned home to discover that established exhibiting organizations were indifferent to works novel in style and content. By founding new organizations, such as the Society of American Artists, the American Water Color Society, and the National Sculpture Society, these artists were able to exhibit advantageously and to attract critical attention. They also benefited from increased public interest in art, attributable in large part to publicity attending the works shown at the Centennial Exhibition in Philadelphia, to the growth of museums and special expositions engendered by post-War urban expansion, and to greater concern with art history and criticism on the part of popular and professional publications.

Late nineteenth-century Americans, energetic and self-conscious in their accomplishments in acquiring, making, and evaluating works of art, produced many ambitious documents of their own complex interests. These books offer crucial raw material for studies of particular collectors, artists, and critics, and for broad ranging examinations of a unique era in American cultural life. The Art Experience in Late Nineteenth-Century America contains a large number of these essential books, which should provide the foundation upon which a coherent image of American activity and taste in the visual arts from the Civil War to the beginning of the twentieth century may be built.

The series begins with a vestige of ante-bellum nationalist optimism, *A Landscape Book, by American Artists and American Authors* (New York, 1868), which is an expansion of an earlier "gift book." In seventeen chapters, it pairs depictions of American scenes by painters associated with the Hudson River School with writings by prominent authors. Accompanying William Cullen Bryant through "The Valley of the Housatonic" and Henry T. Tuckerman "Over the Mountains" with the western pioneers, the reader views American scenery through mid-century eyes and comprehends the reverence that prompted American landscape painters of that era to follow Emerson's dictate to let nature paint "the best part of the picture." The central quotients of romance and religion perceived in American scenery are also evident in Washington Irving's reflections on the mysteries of the Catskills and in Alfred B. Street's description of the "sublime cathedral of nature," the Adirondacks.

Typical of ante-bellum nationalistic and moralistic self-confidence is James Fenimore Cooper's essay "American and European Scenery Compared." Here Cooper gives due deference to the natural attractions of Europe but claims freshness for American scenery and notes its ability to carry the mind to God.

The Art Experience in Late Nineteenth-Century America then concentrates on two groups of books that reflect the loss of national self-esteem after the Civil War and the resultant complexity of American art and taste. The first group consists of books that reveal the period's high regard for European art; the second includes books that seek to stimulate and endorse native efforts and to suggest that a new and great American cultural and aesthetic awakening might be in progress.

James Jackson Jarves' *Art Thoughts: The Experiences and Observations of an American Amateur in Europe* (New York, 1869) is an important document of the perception of the deficiencies of American art in the post-War era and of the belief that understanding of tradition would remedy them. Ever since the mid-1850s, Jarves had sought to develop and improve American taste. In addition to forming an extensive collection of Italian paintings of the thirteenth through the sixteenth centuries in the expectation of selling them to an American public gallery, Jarves produced several didactic and critical books on art. *Art Thoughts* is, in many ways, the clearest statement of his concern with the lack of attention to art in America, his most mature effort "to train the public to comprehend the true nature and functions of art," and probably his most timely publication. Here he offers a discussion of the art-making impulse from antiquity through the nineteenth century in Europe, takes a glimpse at the art of Japan, and appraises American artistic achievements and needs.

The landmark event in the development of late nineteenth-century American art awareness and taste, the event that literally brought the accomplishments of contemporary foreign artists home to Americans, was the Centennial International Exhibition, held in Philadelphia in 1876. The profusely illustrated three-volume critical catalog, *Masterpieces of the Centennial International Exhibition* (Philadelphia, c. 1876-1878), is a fascinating and indispensable analytical record of the immense and varied displays. In volume I, Earl Shinn, painter and, under the pseudonym Edward Strahan, prolific art critic, surveys and appraises the painting and sculpture presented at the Exhibition. These include the many European works whose quality and variety were a revelation to American artists and their patrons. In a volume devoted to Industrial Art, Walter Smith

concentrates on examples of the decorative and more utilitarian arts of the Victorian era shown at the Exhibition. Volume III, prepared by Joseph M. Wilson, combines a useful review of major European and American expositions from 1844 to 1876 with a comprehensive discussion of the history and appearance of the Philadelphia Centennial and a description of the important mechanical and scientific displays.

A number of books published in the wake of the Centennial International Exhibition provide pictorial evidence of, and critical commentary on, the art that Americans had come to regard as worthy of acquisition and emulation. In his survey of *Contemporary Art in Europe* (New York, 1877), S.G.W. Benjamin notes that his subject "especially claims the attention of the American public at the present time." He observes a new and keen interest in art in America and anticipates the development of "the still unformed and unorganized art talent of the community into art schools such as have distinguished the Old World." Significantly, he urges Americans to study the "arts of other ages and races, for the better appreciation of the principles which underlie art growth." His examination of the artists, art organizations, and decorative arts of England, France, and Germany suggests the nature of American quality judgments and aspirations.

Issued serially and then compiled into three immense volumes, Earl Shinn's *Art Treasures of America* (Philadelphia, c. 1879-1882) offers catalogs of and commentaries upon major American collections. Shinn notes that Americans had been accumulating art at a remarkable rate and anticipates that upon publication of his study, "it will be a pleasant surprise to the educated public to discover the masterpieces which are in their midst." In addition to discussing such New York City collections as those of Mrs. A. T. Stewart, John Jacob and William Astor, J. Pierpont Morgan, August Belmont, and William H. Vanderbilt, Shinn examines collections in Washington, D.C., Philadelphia, Baltimore, Montreal, San Francisco, St. Louis, and other cities. Although Shinn notes that at least one collector, Charles S. Smith, was "encouraging American art with liberality and discernment," and another, Thomas B. Clarke, had "a most refined collection" of exclusively American pictures, his commentaries concentrate on the European works for which American collectors had an overwhelming preference. Indeed, Shinn's study is a monument to the astonishing uniformity of American taste in the era after the Civil War, particularly to the devotion to French academic and Barbizon painting. It also suggests the necessity for native artists' emulation of foreign models and for American critics' support of their efforts.

In *Hours with Art and Artists* (New York, c. 1882), George William Sheldon provides informal commentaries on a number of European and American painters, the latter including William Merritt Chase, Winslow Homer, George Boughton, and Abbott Thayer. Sheldon's extensive concern with French academicians reflects late nineteenth-century American interest in that aspect of contemporary European painting and reveals the attitudes of the foreign artists with whom aspiring Americans studied.

One of the most formidable late nineteenth-century American critics, Clarence Cook, was far less sanguine about American accomplishments in art in the past and less optimistic about its future course than most other authors represented in this series. In his three-volume study of *Art and Artists of Our Time* (New York, c. 1888), Cook presents a brief survey of native art, basing his analysis of early developments on William Dunlap's *History of the Rise and Progress of the Arts of Design in the United States*, published in 1834 (not included in this series), and offering a rather random account of the works of his contemporaries. Cook's fundamental belief, anathema to most late nineteenth-century promoters of native efforts and to modern historians of American art, is that "The history of Art in America . . . is little more than a reflection of the art of different countries of Europe." Obviously more interested in the latter, Cook devotes more than two-and-one-half volumes to an analysis of contemporary European art, thus expanding upon such studies as Benjamin's of the previous decade. Drawn from France, England, and Germany, as well as Holland, Belgium, and Scandinavia, Cook's examples again indicate what foreign works late nineteenth-century Americans considered worthy of respect and emulation.

By the 1890s, American taste in foreign painting had become increasingly centered on French works and had expanded to include admiration for Impressionist, as well as for academic and Barbizon, examples. A unique collection of essays, *Modern French Masters*, edited by John C. Van Dyke (New York, 1896), comprises personal reminiscences, accounts of studio talk and procedures, and critical appraisals of twenty major academic, Barbizon, and Impressionist painters by American artists who were their pupils or intimate friends. Among the commentaries are those of Will H. Low on Gérôme, Dwight W. Tryon on Daubigny, Theodore Robinson on Monet, and J. Carroll Beckwith on Manet. This volume offers significant first-person views of American painters' desires for affiliation with French attitudes at the end of the nineteenth century and of the means by which such affiliation was achieved.

Writing toward the close of a period unprecedented in America for its interest in and accumulative aspirations with regard to art, John La Farge observes in his introduction to *Noteworthy Paintings in American Private Collections* (New York, 1907) that "The time seems to have come definitely and almost with the rush one might expect in our form of civilization, for some record of the gathering together of works of art by our people." In two lavish volumes that continue the tradition of Shinn's *Art Treasures of America,* notable critics—La Farge, Kenyon Cox, Sir Martin Conway, and Samuel Isham—appraise five major American collections, including those of Isabella Stewart Gardner and John Hay. Of particular interest is Cox's analysis of the collection of Alfred Atmore Pope, who revealed a notable commitment to modern painting by concentrating on the works of Whistler and the Impressionist circle. Reflecting a desire of the editors, La Farge and August F. Jaccaci, to identify the personality of each collector with his possessions, the five general essays include descriptions of domestic settings as well as of individual paintings. Wilhelm Bode, Roger Fry, Max Friedländer, and a host of other authorities supplement the general discussions of each collection with art-historical analyses of particular works.

Published concurrently with these indications of American interest in European art were books that recorded and encouraged native artists' own efforts. With the virtues of European art acknowledged by collectors, critics, and the artists themselves, these appraisals view the growth of American art since the Civil War (that is, the increasing assimilation of foreign techniques and ideas by native artists) with great optimism and a notable, if confused, nationalism. Didactic and enthusiastic concerning American developments, the authors of these promotional efforts on behalf of American art review the evolution of the native tradition from its earliest phases and collate significant information on the aims, ideals, and works of late nineteenth-century American artists.

The author of *Great American Sculptures* (Philadelphia, 1878), William J. Clark, Jr., is typical of those critics who sought the unabashed promotion of American art and solicited the interest and support of art lovers and patrons in the decades after the Civil War. Clark's introductory chapter on the history of ancient and modern sculpture provides the basis for his survey of the accomplishments of American sculptors of the ante-bellum era and for his enthusiastic analysis of members of the contemporary generation. The latter include those who rigorously assimilated European attitudes and those whom Clark regards as "distinctively American in their culture." Their collective achievements, Clark believes, will add to

"intellectual enjoyment at home" and will serve "to elevate the national character abroad." Clark's historical and critical commentary includes nearly all major nineteenth-century American sculptors. He is also attentive to a number of lesser figures and reserves a chapter for Harriet Hosmer and other women who practiced the art.

Although they are directed to "young people," S. G. W. Benjamin's brief essays on *Our American Artists* (2 volumes; Boston, 1879 and c. 1881) provide important information about many late nineteenth-century American painters, sculptors, and illustrators with respect to whom little material is presently available. In addition to portraits of artists, biographical data, and illustrated descriptions of their studios, Benjamin offers critical analyses of their attitudes and works. These include notes on the technique of William H. Beard, comments on the interaction of technical training and direct contact with nature in the style of Sanford R. Gifford, and remarks on the roots of Samuel Colman's eclecticism. Benjamin also briefly reviews American architecture and devotes a chapter to "Lady Illustrators." Typical of his time is his stated desire to provide through these books "a means for initiating the young into some of the mysteries and attractions of art."

In *Art in America: A Critical and Historical Sketch* (New York, 1880), S. G. W. Benjamin's aims are again nationalistic and didactic. While he feels that "it is yet too soon to look for a great school of art in America," he believes that "the time has perhaps arrived to note some of the preliminary phases of the art which, we have reason to hope, is to dawn upon the country before long." Thus, he presents "a historical outline of the growth of the arts in America." In four chapters devoted to painting and one to sculpture, Benjamin appraises earlier American art in terms of two stages. In the first stage, from the earliest times until 1828, artists "prepared the way for the national art of the future." In the second, from 1828 to 1878, art "began to assume a more definite individuality, and to exhibit rather less vagueness in its yearnings after national expression." The third stage, of course, is the art of Benjamin's own moment, which he enthusiastically describes and analyzes. He notes the growth of "new influences and forms of art expression," including developments in black-and-white media, improvements in architecture, increased activity in the decorative arts and in the areas of art education and exhibition, and sensitivity to the best art of Munich and Paris. His conclusion is an optimistic statement of his firm belief in the continued progress of painting, sculpture, architecture, and the related arts in America.

One of the most serious and ambitious products of awakening art

awareness in America in the years after the Centennial Exhibition was the *American Art Review,* a journal edited by S. R. Koehler. Its founding in 1879 reflected Koehler's belief, stated in the inaugural issue, that "the number of persons directly concerned in art studies, or at least of those deeply interested in the condition and progress of the arts, had sufficiently increased to give it a reasonable hope of support." Noting that Americans were concerned with both traditional and contemporary art and that recent advances in American art were equivalent to advances in art interest, Koehler aimed to abet the progress of art in America by publishing art-historical analysis and contemporary criticism. Two years later, in the last issue of the *American Art Review,* Koehler attributed the journal's failure to the immensity of its programme rather than to lack of interest. He claimed, not immodestly, that even in its brief life the journal had "quickened somewhat the forces which are at work in the healthy development of art in the United States."

The extent of those forces and of their products is evident in another didactic and promotional project on behalf of American art that Koehler undertook in 1882. His stated purpose for this project, *The United States Art Directory and Year-Book* (New York, London, and Paris, 1882, 1884), was to chronicle facilities for "the enjoyment, the study, and the commerce of art." Koehler's notations of exhibitions, sales, prizes, editions of engravings, books, art institutions, and artists are useful and suggestive research tools. By their number and variety, they verify the growth of American art activity and interest. The scholar's only regret is that this series ceased publication in 1884, after only two volumes had appeared. Its place in American art documentation was not filled until 1898, when the *American Art Annual* was founded.

Some years after the demise of the *American Art Review,* many of the articles that it had presented on American subjects were reprinted in two large volumes, *American Art and American Art Collections,* edited by Walter Montgomery (Boston, c. 1889). Among the ninety-five essays presented here are critical monographs on such artists as Elihu Vedder, William Merritt Chase, and R. Swain Gifford, and on others presently more obscure; studies of such groups as the Cincinnati painters who were trained in Munich; excerpts from W. J. Linton's pioneering study of *The History of Wood Engraving in America;* commentaries on American collections; a survey of the development of American stained glass; and a summary of "Tendencies of Art in America," by S. G. W. Benjamin. Signed by a number of influential critics of the era and accompanied by highly informative plates, the articles fully validate the claim of these volumes'

subtitle to excellent writing and illustrations.

During its short span of publication, the *American Art Review* had displayed an unusually strong interest in etching. As Koehler noted in the inaugural issue, he regarded the recent "steady development" of that medium as "an especially noteworthy sign of artistic progress in this country." By publishing plates by American etchers in the *Review,* he hoped to "aid in fostering its growth." After the demise of the journal, twenty of the best etchings that had appeared were reserved for republication in *American Etchings* (Boston, 1886), offered originally in a very small edition. In this volume, Koehler and others provide biographical data on the artists, analyses of the specific works, and notes relating to the general appreciation of the medium. The variety of artists represented as being engaged in experiments with etching, and the range of subjects they chose to interpret in that medium, support Koehler's contention, stated first in the *American Art Review,* that "this peculiarly painters' art . . . though born in the seventeenth century, may, by reasons of its remarkable revival in our own day, be regarded as equally the child of the nineteenth."

More fully than in any other publication with which he was associated, S. R. Koehler's views on native painting in the last quarter of the nineteenth century are explicated in the volume entitled *American Art* (New York, London, Paris, and Melbourne, c. 1886), bound in this series with *American Etchings.* Like other commentators of the period, Koehler sees 1877 as a watershed year in American painting, but he attributes new attitudes not to the Centennial Exhibition so much as to the maturation of artists trained abroad in the two decades prior to the Philadelphia fair. These artists, particularly William Morris Hunt and John La Farge, directed attention to the value of European study; their interests, and those of their followers, prompted the secession of the Society of American Artists from the conservative National Academy of Design in 1877. Koehler regards the SAA exhibitions and others held since 1877 as indicative of a new era in American painting, reflecting more conscientious artistic training, greater individualism, and increased technical sophistication. However, he believes that the aspirations of the artists of the decade since 1877 have not been fully realized. He ascribes this to public indifference to their best efforts and to the resultant inclination on the part of some of the artists to ignore the public's taste and to explore technique for technique's sake. To stimulate an enthusiastic yet critical appreciation of native artists' efforts, to rectify the estrangement between the public and the painters, Koehler proposes a retrospective exhibition of the best American painting since 1877. His book, he says, is a modest substitute for such an exhibition. In

his personal retrospective, Koehler reviews the recent achievements of American landscape, still life, and figure painters, and concludes that although "our artists have done nobly, according to the opportunities given to them," they do not yet "rise above a gentle height." He urges his readers to "be just to our artists" by providing them sympathetic appreciation and meaningful patronage.

Three sumptuous folios published between 1886 and 1890 reveal the commitment of other important critics to the native cause in art. In her introduction to the *Book of American Figure Painters* (Philadelphia, 1886), Mariana Griswold Van Rensselaer, one of the most perceptive commentators on late nineteenth-century American art and architecture, indicates as the aim of this volume the promotion of American figure painting. This branch of art, she notes, had enjoyed tremendous growth since the Centennial Exhibition, supplanting earlier portraiture and vying with landscape. In order that the thirty-five plates of important figurative works by American painters may "speak for themselves," they are presented with no commentary other than relevant poems by American and English writers.

In *Representative Works of Contemporary American Artists* (New York, c. 1887), the second of these folios, Alfred Trumble examines a greater variety of paintings. Calling his book "a missionary in the cause which gave it its existence," contemporary American art, Trumble selects for illustration what he considers the greatest works by the best living painters. Thirty plates are accompanied by specific analyses and descriptions and by general commentary on the artists represented. Trumble's rationale for calling attention to contemporary American paintings in such a lavish way reflects the attitudes of other authors represented in this series and is, therefore, worth quoting:

> The present is a remarkable period in American Art, and every contribution to its history will assume, in the future, an importance which it is not now easy to comprehend. Moreover, at a time when the popular interest in native art is awakening, and the appreciation of the few is commencing to arouse emulation in the many, every intelligent and successful effort to place it in its true light before the world will accelerate the development of its popularity, and aid in rendering its merit comprehensible.

In the third of these impressive promotional publications, *Recent Ideals of American Art* (New York and London, c. 1890), George William Sheldon recalls criticism published in 1855 in the influential journal *The Crayon* that American art suffered from poverty of invention, concentration on the grandiose, lack of subtle treatment, and deficiency in figure

painting. Today, he feels, none of these things is true, and "the American art of the present epoch is different from that of any former epoch and superior to it." Echoing some of the attitudes expressed by S. G. W. Benjamin in *Art in America: A Critical and Historical Sketch* and by S. R. Koehler in *American Art,* Sheldon cites the growth of sound technique among the artists, their assimilation of worthy European models, the improvement in methods of reproduction, and the establishment of exhibiting organizations and prizes as both causal and symptomatic of the vitality of contemporary American art. Sheldon is more generous than Koehler in praising American collectors for encouraging American artists. He notes, correctly, that businessmen rather than men of unusual wealth had undertaken the support of native painters. To prove his contention of increased quality in American art, Sheldon presents discussions of individual artists and analyses of particular paintings selected for reproduction. To justify his inclusion of artists who work abroad, particularly in Paris, Sheldon offers a rationale typical of this era in American art whose basic preoccupation was the assimilation of foreign attitudes: "the American *spirit* wherever its activities are displayed, is still American."

Frank T. Robinson's *Living New England Artists* (Boston, 1888) is more modest in scale, but no less didactic or enthusiastic in tone than the foregoing volumes. Robinson provides personal and generally laudatory essays on twenty-seven artists, many of whom were active in and around Boston. Some of the painters discussed, such as J. Appleton Brown, John J. Enneking, and Childe Hassam, have been the subject of recent scholarly attention. However, others recorded and appraised by Robinson are no less important for an understanding of late nineteenth-century activities in a vital artistic area.

The third group of books in The Art Experience in Late Nineteenth-Century America consists of autobiographies of two sculptors and three painters whose careers spanned the era and whose experiences as students abroad and as practitioners at home reflect those of many of their contemporaries.

Best known for his monumental equestrian portrait of George Washington in Boston's Public Garden, for heroic-sized statues of other Americans, and for a number of ideal works, Thomas Ball was also the author of an unusual and revealing memoir, *My Threescore Years and Ten* (2nd ed., Boston, 1892). Here the sculptor documents his major commissions and describes his struggles to bring them to technical and expressive perfection. He also presents recollections of colleagues in art,

records methods of study and work at home and abroad, and offers advice to young artists based on his view of the evolution of American art through his long career.

The Reminiscences of Augustus Saint-Gaudens, edited and amplified by his son Homer Saint-Gaudens (2 volumes; New York, 1913), is an ambitious autobiographical statement by one of the most successful and enduringly interesting late nineteenth-century American sculptors. Saint-Gaudens' reminiscences indicate the nature of the New York art world in the 1850s and 1860s and the quality of training abroad. His circle of friendships in later decades yields significant recollections of leading artistic and literary personalities, including John La Farge, Stanford White, Henry Hobson Richardson, and Henry Adams. In addition, Saint-Gaudens' own commissions receive ample attention.

In his introduction to *Sixty Years' Memories of Art and Artists* (Woburn, Mass., 1900), Benjamin Champney notes that he had written this autobiography in response to friends' observations that he was "one of the very few links remaining to connect the older generation of artists with the present schools." Born in 1817, Champney was acquainted with such early history painters as Washington Allston and John Vanderlyn, and with such precursors of the Hudson River School as Thomas Doughty and Alvan Fisher. In the 1840s, he traveled in Europe with Thomas P. Rossiter, John Casilear, and John Frederick Kensett, and became the lifelong friend of the latter. Remarkably, Champney's travels abroad and artistic activities at home in the post-Civil War era reflect those of a younger circle of artists, including Robert Wylie, William Morris Hunt, and George Fuller. In addition to offering insights into the ideals and experiences of several generations of American artists, Champney presents critical commentary on the state of American art in the last years of the nineteenth century.

Will H. Low chose to cast his series of Scammon Lectures, delivered at the Art Institute of Chicago in April 1910, into an autobiographical mold. In six essays based on these lectures and published as *A Painter's Progress* (New York, 1910), Low recalls the formation of his early interest in art, his artistic education at home and abroad, and his mature career and travels. As he shared many of the attitudes that affected the artistic development of his contemporaries, and as he offers much professionally analytical and personal commentary on other American and European painters and sculptors, Low's memoirs provide useful insights into the artistic ambiance of the late nineteenth century.

Finally, in *From Seven to Seventy: Memoirs of a Painter and a Yankee* (New York and London, 1922), Edward Simmons records his student days

in Paris, his exploration of painting sites in the English and French countryside, particularly the area around Concarneau in Brittany, his participation in major American mural decoration projects in the 1890s, and his involvement in founding "The Ten American Painters" in 1898. Simmons' reminiscences are particularly useful in that he reflects the attitudes of a number of American artists of his generation, notably their dual allegiance to tradition and to Impressionism.

By documenting collectors' affection for European art, artists' emulation of foreign styles and themes, and critics' enthusiasm for native efforts, the books that comprise The Art Experience in Late Nineteenth-Century America reveal the fascinating cosmopolitanism of the era. Many of these books are important sources in English for scholars who are engaged in reexamining the mainstream academic tradition in nineteenth-century European art. Information on Barbizon painting and Impressionism should also prove useful. For students of American cultural history and for those in the fields of American Studies and American Civilization, these books will provide numerous insights into American economic, social, and philosophical attitudes. Most importantly, these books are invaluable resources for students of American art history who have begun to acknowledge and to explore the importance, the meaning, and the consequences of American efforts to seek reaffiliation with European art and culture in the late nineteenth century.

GREAT

AMERICAN

SCULPTURES.

BEATRICE CENCI.

GREAT

AMERICAN SCULPTURES

BY

WILLIAM J. CLARK, JR

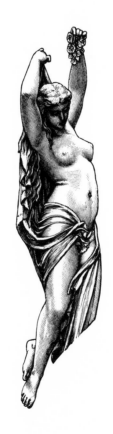

WITH TWELVE SUPERB STEEL ENGRAVINGS, INDIA PROOFS

PHILADELPHIA

GEBBIE & BARRIE, PUBLISHERS

1878

The Table of Contents.

CHAPTER V.

CHAPTER VI.

CHAPTER VII.

CHAPTER VIII.

LIST OF ENGRAVINGS

AMERICAN SCULPTURES

CHAPTER I.

ANCIENT AND MODERN SCULPTURE

THOSE who are unwilling to go further back in their speculations upon the origin of sculpture than positive evidence will carry them, attribute the invention to the ancient Egyptians, and they find an argument in the highly-finished system of hieroglyphic, or image-writing, which that people carried to such perfection, and imagine it to have furnished the first rudiments of sculpture. That this is a probable and natural origin of the practice, (as, beyond all question, it is,) furnishes no argument which is not perfectly available to those who would contend for the probability of its having existed from a period far more remote. All the most ancient writings extant are in a language which, without regard to the *characters* by which these writings were described and per-petuated, is hieroglyphic or picture-writing—every word being, as respects its *expression*, as nearly as possible a picture or an image. It is in vain to inquire now how such figurative words should have first occurred to the imagination; but their having done so shows the natural resort of

9

the mind to express immaterial thought by material forms, and one sensible object by means of another,—and goes, in the next stage, to explain the reason which suggested the *figurative* mode of their written transmission. "The author of a figurative expression must have a figurative idea in his mind; and that is a hieroglyphic which might as well be painted or sculptured as written, and with infinitely greater effect on the reader." But the very same necessity for hitting on expedients for the transmission of thought must have existed long before the days of the Egyptians; and the universal principles of the human mind, impelled by the same urgency and subjected to the same natural and moral influences, would probably act uniformly, and tend to similar results. That such was the case with the Mexicans, who practised an ideal, or picture-writing similar to that of the Egyptians, when first discovered by the Spaniards, strongly supports this view of the case; and it may be added, in reference to the first step of this theory, that the language of our own Indian, when first he was seen on his hunting-grounds, had a figurativeness of thought and expression more than Orientally picturesque. It is impossible to conceive (even were there none of what may be called secondary evidence to the contrary) that man should have lived between sixteen and seventeen hundred years from the Mosaic era of the creation to the Flood of Noah, without inventing some method for the perpetuation or transmission of his thoughts; and not likely that he should, under identical influences, have been led to different modes from those which we know to have uniformly suggested themselves, in the same circumstances, elsewhere. In falling in, therefore, with the general belief that hieroglyphic writing furnishes the first rudiments of sculpture, we find in it a reason for supposing that the latter must have existed, as an art, amongst the nations of the antediluvian world. For ourselves, indeed, and as a matter of conjecture, we can have very little doubt that, like the other arts, it had in all probability attained a point of perfection ere the flood far beyond that to which the inferences already

mentioned lead, and at which they leave us. The manner in which the Arts of Design grow out of each other (the principles of two of them— painting and sculpture—being precisely the same, up to the point at which they separate, one for the imitation of colour, and the other for that of actual and rounded forms) renders it unlikely,—admitting what we have endeavoured to argue for, that the first stage had been attained,—that the restless and enterprising mind of man should have paused over its imperfect knowledge, for a period of which the post-diluvian world furnishes no example. But, the fact is, we find mention made in the Scriptures, long before the flood, of a *city* built by Cain, the inhabitants of which are distinguished from "such as dwell in tents," in a manner to create the inference that it must have been composed of dwellings having some architectural pretension; and, but a few generations later, we have it stated that Jubal was "the father of all such as handle the harp and organ," and Tubal Cain the "instructor of every artificer in brass and iron," leaving it to be undoubtedly deduced that the arts, both of life and taste, were progressing in influential connection. And in truth the inference is irresistible, that both art and science must have made considerable progress amongst a people furnished with the skill and possessed of the implements necessary for the construction of such a vessel as the ark. We find, too, at a period little remote from the subsiding of the waters, works undertaken of such gigantic enterprise, and implying such an acquaintance with the principles, at least of *science*, and their practical application, as do not permit us, from any other experience which we have of the progressive nature of knowledge, to believe that such an acquaintance could have been the entire growth of the period since the flood, and compel us to suppose that it formed a part of that legacy from the old world to the new, which Moses—the orphan of the one and the patriarch of the other— was appointed, by the aid of his family, to take charge of and dispense.

Two generations only after the flood, "when men began to multiply upon the earth," we are told that Nimrod's followers built, on the plain of Shinar, "a city, and a tower whose top should reach unto heaven;" and we have allusion to the manner in which they made bricks and prepared mortar for that purpose. We have, at any rate, evidence to show that the Chaldeans were in possession of the art of sculpture, at least in its early stage of hieroglyphic writing, before the Egyptians. Berosus relates that the temple of Belus, at Babylon, exhibited on its walls, representations, both in sculpture and painting, of all the terrific and monstrous forms which peopled chaos, previous to the creation. And as Chaldea was the first region of the earth which was peopled after the flood, and it further appearing, from Berosus and from Pliny, that the art of engraving on bricks, baked in the sun, was there carried to a considerable degree of perfection, at a very early period (not to mention the eastern tradition which asserts that Terah, the father of Abraham, was a sculptor), the probability seems, for all the reasons which we have given, very strong, that that people derived their knowledge of the rudiments of sculpture from their antediluvian progenitors, and transmitted the art to their Egyptian neighbours.

Mr. Bromley, in his History of the Fine Arts, has laboured to prove that the invention of sculpture, as an art, is due to the Scythians; who, according to him, as early as 300 years after the deluge, extended their conquests over the greater part of Asia, under Bruma, a descendant of Magog, the son of Japhet, and author of the Braminical doctrines, and diffused the principles of the Scythian Mythology over Egypt, Phœnicia, the Asiatic Continent, and Greece. Herodotus, on the other hand (whose researches on this subject were made in the countries themselves of which he speaks, and whose veracity and correctness of view have been confirmed by each new accession which has been made to our knowledge of them, in modern times), expressly assigns its origin to the Egyptians. It seems

useless, however, to follow up an inquiry the links of which are so involved, at times, and at others so broken and scattered, by the casualties of ages, over the countries to which it refers. We have alluded to these conflicting theories, as showing that, wherever a vestige of substantial evidence can be traced, or an argument from inductive evidence drawn, they at least combine to prove the universal existence of the practice of sculpture, however derived. For ourselves—believing, as we have already said, in the first instance, that it is one of those modes which would most obviously suggest themselves, everywhere, in the earliest stages of society, for the expression and communication of thought, and that it would, in an order as natural and uniform, be very early advanced into a vehicle for the perpetuation of feeling and sentiment, whether religious or domestic, whether of the imagination or the heart; and believing, also, as regards the apparent order of its real and actual transmission, that it must have attained some degree of perfection before the flood, and been reproduced, with the other arts of life or taste by its survivors, upon the plains of Chaldea, and by them, of course, carried in their migrations to those other lands which they peopled;—believing, thus, that the chain of its existence is unbroken, at least in the East, it must still be admitted that the chain of evidence is *not;* and, were we writing a *history* of the art (which we are not), we should be compelled to place the commencement of its authentic records in Egypt or Hindustan, where first begins the positive testimony derived from a vast body of actual remains. From this period, we are able—notwithstanding the ruin and desolation which have overwhelmed most of the Asiatic empires, and brought the desert on to the site of their stately cities—to trace, in a tolerably connected series, the steps by which it has descended to Western Europe, and to our own day. And though this is the office of the historian, rather than the purpose of these introductory remarks, yet a slight sketch of its progress, will, necessarily, be given in our attempt to point out the principal

periods at which it flourished, and the long and painful march by which it attained to perfection.

The earliest written mention of the arts of design which we possess is in the oldest of our books—the Bible; and (pointing to a period antecedent to that at which the descendants of Abraham had the opportunity of learning the arts and the idolatry of the Egyptians by residence amongst them) comes in corroboration of our belief that the art in question had been saved from the wreck of the old world, by the original dwellers in Chaldea. The first notice of images occurs in the book of Genesis, where Rachel is said to have stolen the Teraphim, or idols, of her father Laban, the Syrian, and carried them with her into Canaan:—and, shortly afterwards, we have an order of Jacob's, to his household, to deliver up to him their idols. In the same book, mention is also made of the signet of Judah. From this time the Sacred Scriptures furnish us with continual allusions to, and evidences of, the practice of sculpture—both in the service of idolatry, such as the Israelites had learnt it in Egypt (as in the case of the golden calf, made by them, under the directions of Aaron, during the absence of Moses in the mount, and which, no doubt, represented the Egyptian Apis), and in the service of their own religion, as appointed by the express ordinance of the true God. The earliest sculptors whose names have come down to us, Aholiab and Bezaleel, received their commission and their inspiration directly from the same source; and were appointed by the Most High himself to fashion the works which He prescribed as the adornments of His tabernacle, and to sculpture the cherubim, whose wings were destined to shadow the ark of His covenant. It cannot be overlooked, in any work which professes to describe, however cursorily, the progress of this art, that it was thus early adopted by God himself into the service of His own religion, and promoted by Him to the most important purposes—the representation of divine attributes, or

of the symbols of divine providence. After the establishment of the Israelites in Canaan, there are continual indications of Hebrew art—from the allusion contained in the Song of Deborah and Barak, to those who delineate with the pen or pencil of the writer; and the mention of the images (graven and molten) made for Micah, down to the account of that most magnificent production of all, the Temple of Solomon, on which were lavished all the resources of surpassing wealth, and, it is not to be doubted, of consummate art. Of these specimens of early sculpture, however, we have nothing left but the written records, which derive—as, in this case, they happily need—no corroboration from existing monuments. The utter devastation which has overwhelmed the lofty cities of Asia, once the seats of arts and science, has swept away all memorials of the old Patriarchs—of Moses the deliverer, and even of the gorgeous Solomon, whose works were so many and so vast, that the traditions of the East suppose him to have ruled by talismans, and worked by the aid of genii. Of the whole labors of Jewish art, but one solitary remain has come down to our times—viz. the sculptured bas-relief on the arch of Titus. As for the monuments known as the Sepulchres of the Prophets, which exist in Syria, at the present day, they bear undeniable evidences of Roman or Greek origin, and must have been erected at a period long subsequent to the days of the prophets. Neither is our research after the sculptured memorials of Nebuchadnezzar, of Semiramis, or of Belus, more satisfactory. We are, again, confined to the written record. We have no means of knowing what kind of a "golden image" it was which "Nebuchadnezzar, the king, set up." From Herodotus, we have a description of the temple of Jupiter Belus, at Babylon, with its statues of solid gold; and Diodorus Siculus has described the sculptured palaces which Queen Semiramis built in the city of the Euphrates. But Babylon herself affords no evidence of her former grandeur;—"the wild beasts of the desert lie there," as Isaiah prophesied they should—the "daughter of the Chaldeans" hath long since

"gotten her into darkness"—the "virgin daughter of Babylon" hath, indeed and literally, "come down to sit in the dust";—and from her buried soil, the "lady of kingdoms" yields up no memorials of her ancient sculptures.

The Persians are not supposed to have ever made any distinguished figure in the arts of design; for which two reasons have been assigned. The long, flowing robes which composed their dress, and concealed the person, prevented them from paying much attention to the beauties of form; and the genius of Mithraism, their religion—in which the Deity was worshipped, in the symbol of fire, and which taught them that it was impious to represent him under a human form—rendered their exercise of the art of sculpture, at least in the branch of statuary almost impossible in that country—it not being their custom to raise statues to their illustrious men. Herodotus says that the Persians had neither temples nor statues.

Nevertheless, although totally absent amongst them one of the impelling causes to which the arts, elsewhere, have owed their encouragement and progress (though not, as has been said, their origin), the giant ruins scattered throughout the dreary solitude of the vast deserts which form a great part of the site of the ancient empire, present sufficient remains of sculpture to enable us to form a correct notion of the degree of excellence to which it had attained amongst this people. They exist, as may be supposed, from what we have said, principally in the embellishment of the "house of feasting" and the "house of mourning" —the palace and the tomb. Of these, the ruins of Persepolis offer, in what remains of its palace (the ancient abode of the Persian monarchs, described, by the Persian writers, as the "palace of a thousand columns," and destroyed by Alexander), a good example, as do also the sculptures on the Tombs of the Kings. They are very rude, giving the idea of art in its infancy, although their antiquity is not supposed to go higher than

the period when the seat of empire was removed from Babylon to Shushan, by Darius Hystaspes, the Ahasuerus of Scripture. They are, like everything about them, on a giant scale; and the basso-relievos on the walls are said to have some resemblance to the style of the Egyptian basso-relievos, found amongst the ruins of Thebes. Memes speaks of them as bearing decided traits of the Grecian school, and assigns them to an age subsequent to that of Cyrus. Thirteen hundred figures of men and animals have been counted, as remaining in the vast ruins of the palace of this pillared Persepolis alone, once amongst the wonders of ancient Asia, and now one of the miracles of the desert. But few sculptured remains are found amid the gigantic masonry of Baälbec—the ancient Heliopolis, or City of the Sun. Palmyra, the Tadmor of the wilderness, mentioned in the Book of Kings, as having been built by Solomon, exhibits ruins more properly architectural than sculptural; but what there are of the latter are referable to a far later period, belonging to the times of Hadrian, and the other Roman emperors, who rebuilt this city. The Tadmor of Scripture has long since disappeared. Of the ancient Tyre—the "joyous city"—the "renowned city"—as the prophet calls it (destroyed by Nebuchadnezzar), and its Hercules, described by Ezekiel, no relic is left; although Herodotus, who sailed in search of it, saw and describes the temple, but without its god.

As examples of Hindoo art, it is only necessary to allude to the stupendous excavations of Ellora and Elephantis, and the vast caverns cut everywhere along the banks of the Ganges, sculptured all over with mythological personages and allegorical figures, illustrative of the religion of Brahma. In Egypt,—which, according to Herodotus, is said to have once contained 20,000 populous cities, and where everything connected with the labour of man appears to have been on a scale which has something like the same relation to modern artificership, as that presented by the

giant features of American nature when brought into comparison with the more minute and beautiful character of European scenery,—we have still, besides the Pyramids, the remains of five immense palaces and thirty-four temples, including gigantic statues, and sculptural representations innumerable, to astonish and instruct us. From Herodotus, besides, we have minute descriptions of much that is now lost or scattered by the lapse of ages and the tempests of war. It is not possible here to do more than allude by name to some of these amazing works; and neither is it necessary, as the lights thrown of late years upon Egyptian antiquities by many publications have rendered them more familiar to most of our readers than are the monuments of our own country. In Egypt all is colossal. The two statues mentioned by Herodotus as placed, one in front of the temple of Vulcan, at Memphis, and the other in the city of Sais, each seventy-four feet in length; the two supposed statues of Memnon, at Thebes, each fifty-eight feet high; the Sphynx, modelled upon a rock ninety-five feet in length, and having thirty-eight feet in height, from the knees to the top of the head, are (to say nothing of the Pyramids) examples. The great temples of Karnac and Luxor, on the right bank of the Nile (which, together with those of Medinet Abou and the Memnonium, on the left bank, are supposed to occupy the site of the ancient Thebes); the temples of Hermopolis, Dendera, Latopolis, Apollonopolis; and those of the islands of Philae and Elephantine, all present ruins, crowded with statues, and covered in pillar and portico, within and without, with hieroglyphical representations, connected with the mysteries and sacrifices of their worship. The earlier of these statues, those executed previous to the conquest of Egypt by Cambyses, the son of Cyrus, and, indeed, we may say, down to the time of the Macedonian conquest, under Alexander the Great (for the Persian sway rather put a negative upon the exercise, than changed the forms of sculpture), exhibit the entire absence of almost all those resources by which the art was finally perfected, including the total

want of anatomical, and lamentable deficiency of mechanical, knowledge. Yet an air of imposing grandeur and majesty is communicated to many of them, in the absence of all symmetry and all expression, not only by the breadth and simplicity of their proportions, but by the air of passionless calm and superhuman repose which that very absence creates. Of Egyptian art, in general, we may add, that it wears a character of the sublime, and creates an impression of the awful, at once from the vastness of its dimensions, and the solemn nature of the purposes to which it is applied. The sculptures of Egypt are chiefly employed either in the decoration of the tomb, or the illustration of a religion whose mysteries are almost as dark and awful as those of the grave itself; and, in either case, the effect is heightened and solemnized by the manner in which this species of illustration is employed. The whole of the Lybian mountain is pierced, from its base to three-fourths of its elevation, with sepulchral grottos, containing long passages, supported on innumerable columns or pilastres, and conducting, gloomily, to chambers of the dead. In a ravine of the mountain, flanked by the bed of a torrent, stand the Tombs of the Kings, composed of galleries and corridors, crowded with pillars, and opening on saloons, whose walls are covered with pictures and sculptured hieroglyphics. The quarries of Silsilis, in Upper Egypt, present, also, funeral chambers and passages, containing figures, as large as life, cut in the native rock; and all along the borders of the Nile are found tombs, similarly piercing the bases of the heights, and surmounted by porticos, entablatures, and cornices, all hewn out of the solid granite. Such are the sublime characteristics of the art, in a country in which the natural quarry itself has been made the chamber of sculpture, and the living mountain the block !

On the subject of Egyptian sculpture we can only add, that after having been ransacked by the Macedonian Conqueror, for the purpose of

adorning his rising city of Alexandria, it puts on new forms, or rather modifications of form, under the influence of Greek art, in the reigns of the Ptolomies; and more conspicuously so under the dominion of the Romans, in the days of their emperor Hadrian.

Of Chinese sculpture, as of everything else relating to that singular and ingenious people—who lay claim to a higher antiquity and earlier cultivation than any other nation—our knowledge is, from their exclusive policy, too limited to speak with anything like certainty. Specimens of their ornamental carving have reached us, of the most minute and elaborate beauty of finish; but in sculpture, as an intellectual art, or in any of its higher walks, we have no reason to suppose that they have attained to any proficiency. As the best authorities concur in the belief that China was originally colonized from the banks of the Indus and the Ganges, it is probable that they took with them, at a very remote period, the arts of India, in their earliest state of advancement; and the jealous system of the empire, which has so long shut them within their own limits, and prevented that intercommunication by which knowledge is promoted, has, in all probability, in this—as we know it has in other things—confined them to ancient forms, and retained amongst them primitive modes of thought. Unchanging customs, of the standing of thousands of years, and manners such as might have existed soon after the Deluge, are, in all probability, connected with manifestations of feeling and methods of expression, in the article of art, which might introduce the antiquary—could he obtain leisure and unlimited access to them—to something like an acquaintance and communion with the immediate descendants of Noah. This belief receives confirmation from such of their medals and bronzes as we have seen. Within the last few centuries, however, they are supposed to have received some glimpses of European improvement, through the teaching of Christian missionaries from the west—and more especially of the Jesuits, who went

over in the beginning of the seventeenth century; so that even this remote and inaccessible nation may be said to have felt the universal influence of Greek art. In the reign of Louis the Sixteenth, a number of Chinese were sent to Paris, to be instructed in the European arts of designing, light and shadow, optics, colour, and perspective; and, since then, it is generally believed (and probable) that, both in painting and sculpture, they may have improved their ancient modes, by a more spirited cultivation of these arts, and an assimilation to the practice of European nations. The tendency of their participation in all recent International Exhibitions, including that of Philadelphia in 1876, shows a marked departure from their old exclusiveness.

We have now reached a part of our subject which presents more open and beaten ground; and which, for that reason, as well as on account of our limited space, must be passed over in a rapid review. The point at which we have arrived may, in fact, be said to divide the subject into two parts;—our past inquiries have been limited to that species of evidence which arises from the *post mortem* examination of the ruined works themselves, or from the analogies which their condition presents, but receiving no light from the positive testimony of written and contemporary annals; whereas we are able, from a period shortly subsequent to that which we have now attained in this sketch, to trace our onward way by the light of history, and to follow, with something like certainty, the progress of the art in the hands of that extraordinary people who stamped it—as they did so many others—with the seal of their own unrivalled genius; and brought it to a perfection undreamt of old, and unsurpassed since; who rendered it, in a word, a fitting vehicle for the expression of the purest and most beautiful and ideal mythology which the world had, or has ever invented.

Of the earliest state of Greece, the accounts which we have are, in a

great measure, fabulous; but there is little doubt that she was, originally, civilized by colonies from Egypt and Phœnicia; who brought with them the religion, letters, and arts, of their parent country, and sculpture among the rest. That the gods of Greece were of Egyptian and Phœnician extraction, is undeniable. Of the condition or progress of art in Greece, however, previous to the time of Dædalus, we have but few hints,—although it is probable that the little state of Sicyon (whose academy of design became, subsequently, one of the most famous in the land, and on which has been conferred the venerable appellation of "Mother of the Arts"), was signalized by the earliest school of Greek sculpture, as it was certainly the most ancient of the Greek republics. The beautiful story narrating the accidental circumstance in which this school had its origin, and which makes love the parent of the arts of Greece, must not be omitted here. Its foundation is attributed to a Sicyonian potter named Dibutades; to whom the practice of modeling is said to have been suggested by an ingenious device, imparted to his daughter by her own fond and grieving heart. On the eve of bidding farewell to her lover, who was about to depart on a distant journey, her eye was caught by the profile of his features, thrown upon the opposite wall, from a lamp, by whose light she watched him as he slept; and affection inspired her with the idea of fixing the outline there, by tracing round the shadow, for the solace of her lonely hours in his absence. This outline the father subsequently filled up with clay,—thus forming the most ancient medallion; and this specimen of antique art existed (and both from the pathetic nature of its origin, and the important results to which it subsequently led, was regarded with the highest interest) down to the time of the elder Pliny. Such is an example of the beautiful traditions which, in this country insensibly sprang up, and associated themselves with all the doings of its refined and spiritually minded people; and the fine sentiment in which they originated, constitutes the true charm by which they worked their miracles, in every department

of art, and whose various manifestations have invested all the scenes and records of the land with the poetry of graceful and undying thought.

Another of the oldest of the Greek schools of sculpture, and one which, likewise, subsequently arrived at the highest eminence, arose in the small commercial island of Ægina; and was early illustrated by the labours of Smillis, whose works are said, even in that remote age, to have displayed "a gravity and austere grandeur, the principles of that style visible, still, in the noble marbles which once adorned, in Ægina, the temple of Jupiter Panhellenius." But the first epoch of improvement in Athens—afterwards the metropolis of the arts—is connected with the name of Dædalus, the famous builder of the Cretan labyrinth, and cotemporary of Theseus, whom he accompanied from Crete to Athens (having, it is said, previously executed a fine portico to the temple of Vulcan, at Memphis), and settled there about 1200 years before Christ. According to the testimony of Pausanias, his works, though rude and uncouth, had yet "something as of divinity in their appearance;" although his statues (as well as those of his disciple, Endæus) were merely formed of wood. The Ionian school, about 777 years before Christ, produced, at Samos, Rhæcus, who first obtained celebrity as a sculptor in brass; and in the following century, at Chios, Malas, the father of a race of sculptors, and who first introduced the use of the material to which sculpture mainly owes its perfection— viz. marble. Towards the commencement of the next century, the school of Sicyon was illustrated by the most famous of her ancient masters, the brothers Dipænus and Scyllis, "whose age," says Memes, "forms an era in the history of the ancient art, making the first decided advances towards the mastery of the succeeding style." Of the previous condition of the art, in which the genius of these brothers is stated to have effected so material an improvement, some idea may be obtained from an examination of the colossal busts of Hercules and Apollo (conjectured to be the work

of these masters), now existing in the British Museum. "The fiftieth Olympiad," says the author above quoted, "shows all the necessary inventions and principles of mechanical art fully known, and universally practised." Cotemporary with the slow progress of art in Greece, the school of Magna Græcia,—whose chief seats were at Rhegium and Crotona, in Italy; and in Sicily, at Syracuse and Agrigentum,—had been rising into importance and excellence, through a period of 2000 years. During the former part of the sixth century, the school of Sicyon retained its pre-eminence; sending forth from its bosom numerous artists, who maintained its cause in other states. Among these were Perillus, at Agrigentum, who cast the famous bull of Phalaris. The close of the same century produced, at Chios, the two brothers Bupalus and Anthermus, who threw all preceding sculptors into shade. In their hands the discovery of their ancestors, sculpture in marble, made rapid strides to perfection; and from their days down to the period of the battle of Marathon, the art was exercised, throughout the whole of Greece, with a vigour unknown before, and continually gaining strength. It was during this period, that, under the enlightened patronage of Pisistratus (a prince, or tyrant as he was called, who first sought to give his country the empire of literature and the arts), the foundations were laid, at Athens, of that greatest school, whence afterwards issued the miracles and canons of sculpture. Amongst the names of the illustrious men whom he assembled around him, we find the famous one of Callimachus; whose sculptural compositions were distinguished by that lightness and grace, the perfection of which, in the hands of Praxiteles, subsequently gave the finishing and unsurpassable charm to this, at length, enchanting art. Out of the numerous productions of the same period, in other parts of Greece, we must select, for mention, the two Muses of Canachus and Aristocles, issuing from the school of Sicyon,— esteemed, in that day, the finest statues as yet executed, and one of which is conjectured to be the famous antique now in the Barbarini palace. But

rich as this period is in names and works which history has transmitted to us, we must hasten forward to the last grand era in the upward progress of Grecian sculpture. Indeed, our limits have not permitted our doing more than pass hurriedly over the ground which conducts to this point; our object being to trace the progress of sculpture, by its eras, without permitting us to give a list of the many names who contributed to produce them.

From the time of the battle of Marathon, 490 B.C., down to that of Phidias, we find amongst the names of those who illustrated and carried forward the art, in its now rapid and energetic march, those of Calamis, famous for his horses, and whose statue of Apollo Alexiacos, the Deliverer from Evil, mentioned both by Pliny and Pausanias, is believed by the learned Visconti, to be the famous Apollo Belvidere; Pythagoras of Rhegium, whom Quintilian places only below Myron; and Myron himself, whom Dr. Memes calls, "the last and greatest of the early school." Of this artist's works nothing has descended to us; and our only means of forming a personal judgment of his skill are derived from the antique repetitions of his Discobolos, more than one of which have reached our times, and of which there is an ancient example in the British Museum. But we learn from the writers on that period of art that sculpture, as far as it is a representation of external form, was perfected by him, and prepared for the infusion of that spirituality—that fire from heaven—which, in a few years more, it was to receive at the hands of the Prometheus of the art.

The merits of this great artist (born about the 72nd Olympiad) are too well known to require that we should dwell upon them. It is sufficient to observe that Phidias brought to the exercise of an art, already advanced before his day to an excellence far surpassing anything of which the

ancients had left an example, a genius of the very highest order, steeped in the inspiration of the poets, and tutored by the wisdom of the philosophers. By communicating to the perfect forms which his predecessors had bequeathed to him that inspiration, governed by that wisdom, he raised sculpture to take her place amongst the very first forms of art,—aye, on a throne than which there is none higher; communicating to it all the power which the highest poetry has for elevating the imagination, or touching the heart. In addition to this he gave, in his execution, a softness to flesh, and a flow to drapery, unknown before his day. Two of his productions, the most esteemed amongst his cotemporaries, were his ivory statues of the Athenian Minerva and the Olympian Jupiter; of which Quintilian says, that they "*seemed to have added something to religion—* the majesty of the work was so worthy of the divinity." The latter, and most colossal of these, is described by Flaxman as follows: "The great work of this chief of sculptors, the astonishment and praise of after-ages, was the Jupiter at Elis, sitting on his throne, his left hand holding a sceptre, his right extending victory to the Olympian conquerors, his head crowned with olive, and his pallium decorated with birds, beasts, and flowers. The four corners of the throne were dancing Victories, each supported by a Sphynx, tearing a Theban youth. At the back of the throne, above his head, were the three Hours or Seasons, on one side, and on the other, the three Graces. On the bar between the legs of the throne, and the panels or spaces between them, were represented many stories;—the destruction of Niobe's children, the labours of Hercules, the Delivery of Prometheus, the Garden of Hesperides, with the different adventures of the heroic ages. On the base, the battle of Theseus with the Amazons; on the pedestal, an assembly of the gods, the sun and moon in their cars, and the birth of Venus. The height of the work was sixty feet. The statue was ivory, enriched with the radiance of golden ornaments and precious stones, and was justly esteemed one of the wonders

of the world." Dr. Memes describes it as "in a reposing attitude, the body naked to the cincture, the lower limbs clothed in a robe gemmed with golden flowers; the hair also was of gold, bound with an enamelled crown; the eyes of precious stones; the rest of ivory. Notwithstanding the gigantic proportions, every part was wrought with the most scrupulous delicacy; even the splendid throne was carved with exquisite nicety." The Minerva of the Parthenon was a figure forty feet in height, similarly executed, in mixed materials, some years later, and wrought with equal delicacy and beauty. Of both these statues we have minute and laudatory descriptions from Pliny and Pausanias. Yet, the fact of the Athenians having preferred these splendid productions (in which the effect was sought to be heightened by the meretricious use of foreign accessories) to the unrivalled specimens of pure and self-expressive sculpture which the same master produced, proves that they were behind the sculptor, as regarded the true principles of taste; and that the great artist (who is said to have disapproved of this mixed style) had the weakness to suffer his own judgment, at times, to be controlled by the less-instructed spirit of his age. But it may be that he gave way only to obtain a vantage ground, from which he might lift up the public mind to his own standard; and his subsequent example did much to establish those canons of pure taste, which the world has not yet seen reason to alter. Both these magnificent works, together with the whole of the statues executed in bronze, by Phidias (a branch of the art which he is said to have carried to a perfection never rivalled), have perished; and our personal inquiries into the style of this consummate artist are limited to those marble remains of the produce of his chisel, which have survived his labours on the more durable material. Fortunately, they exist in unquestioned authenticity and sufficient abundance for our purpose,—although in this department, also, many of his finest performances have been lost. Indeed, the number and extent of the works performed by, or under the immediate direction

of, Phidias, are so great as to fill the mind with wonder, and almost disbelief; and, true it is, that so numerous and active was the school of art which he founded, and so illustrious were its pupils, that we are not able, with the assistance of the ancient writers, to separate, in all cases, the actual works of the master from those of his scholars, which he superintended, and to which he gave the finishing touches.

Of the scholars and cotemporaries of Phidias, and of the distinguished artists who, from the death of the great Athenian, carry forward the history of sculpture to the age of Alexander, we can do little more than merely allude to the names of a few. The Venus Aphrodite, which has given fame to Alcamenes, the pupil of Phidias, is said to have received its last touches from the master's hand. To Polycletus, one of his cotemporaries, has been, by some, attributed a grandeur of style approaching to that of Phidias himself. Of his two celebrated statues, the Diadumenos and the Doryphorus, the latter formed the famous "canon of proportion," to which all succeeding artists referred, as to an unerring rule. The celebrated statue of the "Dying Gladiator" (more properly, as Winckelman thinks, a dying herald or hero), one of the finest examples of Greek art in existence, has been commonly ascribed (some think erroneously) to Ctesilaus, a rival of Phidias. Of the artists who flourished during the troubles of the Peloponnesian war we have accounts, or casual notices, of nearly fifty, in the writings of Strabo, Pausanias, Pliny, and others. To Scopas are ascribed the Townley Venus or Dione, now in the British Museum, and the beautiful group of Niobe at Florence. Winckelman has well divided the history of Grecian art into four periods, distinguished by four styles. These he calls the *Ancient* style, which ascends from the time of Phidias back to a period beyond authentic record; the *Grand* style, formed by Phidias himself; the *Beautiful*, introduced by Praxiteles and Lysippus; and the *Imitative*, practised by those artists who copied the works of the ancient masters.

Between the second and third of these the name of Scopas may be placed, as conducting us, by a gentle gradation, from the school of the Grand to the school of the Beautiful; and already exhibiting, in his works, much of that seductive softness and winning grace which characterized the practice of Praxiteles, to whose name we must at once turn.

This great sculptor (the place of whose birth is uncertain, though supposed to have been one of the towns of Magna Græcia) has a name in Greek art second only to that of Phidias; and which, perhaps, need scarcely be placed in a lower rank, when it is considered that he selected for himself a somewhat different walk, probably not more from the bent of his taste than from his wish to avoid such a comparison. The highest point of the sublime had been touched by the chisel of the Athenian; and his successor devoted himself to the worship and illustration of beauty. His compositions are full of a tender and voluptuous grace, corrected and chastened by a spirituality which redeems them from the charge of the sensual. The most celebrated of his works, which have perished, are the two statues of Venus, one draped and the other naked, which he made for the selection of the Coans, who chose the clothed figure. The other was subsequently purchased by the citizens of Cnidos, and became one of the most celebrated statues in the world, to see which Cnidos was visited from many parts beyond seas. This figure was placed in a temple open on all sides, that it might be seen in every point of view. It is known to us by the description of Lucian, and by a medal of Caracalla and Plautilla, in the cabinet of France, on which it is represented. It remained in Cnidos as late as the reign of the Emperor Arcadius, four hundred years after Christ; and is supposed to have furnished the first idea of the Venus de Medicis, which is considered likely to be a repetition of another Venus, mentioned by Pliny as having been executed subsequently by Praxiteles. The Venus of Cos is supposed to be the same as that

one, with an apple in her hand, who is represented on the reverse of the Empress Lucilla's medals. The works of this artist which remain, either as originals or in repetition, are his Cupid, Apollo, the lizard-killer, Satyr, and Bacchus, leaning on a fawn.

Of the 610 works, chiefly in metal, ascribed to Lysippus, the cotemporary of Praxiteles, and his rival in the favour of Alexander, we have no remains. He was, like Praxiteles, a worshipper of the beautiful, and has left behind him a reputation scarcely inferior to that of the great founder of the school in question. Notwithstanding, however, the exquisite delicacy of conception which has been ascribed as one of his characteristics, there appears, at times, in the selection of his subjects, and his manner of executing them, an occasional leaning towards the more sublime style of their illustrious predecessor. Amongst his works were a statue of Jupiter, 60 feet in height, and twenty-one equestrian statues of Alexander's body-guard, who fell at the Granicus.

That the earliest inhabitants of Italy, whencesoever sprung, were sculptors after the rude fashion, which we believe to be common to all barbarous nations, we have no doubt; but the practice of sculpture, as anything like an art, is commonly supposed to have travelled westward to them by the road of Greece. The accounts given by the Greek writers concerning the emigrants into Italy, who settled along the western part of that coast (forming the colony, of whose *later* school of art we have already spoken, as that of Magna Græcia), together with the evidence derived from an inspection of their remaining works, have led admitted authorities to the conclusion that the Etruscan remains are either the productions of the Greek colonists themselves, or of those who received instruction in art at their hands. There is, however, good reason to suppose that the transplanted art found a soil more rapidly propitious than that

from whence it had been derived; and that the school of sculpture in Etruria had early arrived at a degree of refinement not attained by Greece until a later period. The Etruscan gems and medals of that period, which have come down to us, are of wonderful beauty for so remote an age; but the most numerous class of these remains are their engraved bronzes, or sacrificial vessels, called Pateræ. Of the ancient statues and relievos which have been discovered in Italy, there is some difficulty, from this relationship and identical character of the two schools, in separating those which are of Etruscan workmanship from those which may be of Greek importation. The figures of the Roman kings and other illustrious persons of early times, mentioned by Pliny as standing in the Capitol—together with the terra-cotta figure of Jupiter Capitolinus—are supposed to have been from the schools of Etruria; as well as most of the other works of sculpture executed for the early Romans; whose acquaintance with Grecian art seems to have been very limited before the time of the Scipios. The arts of Etruria flourished in her twelve capitals in emulous and increasing splendour, until her once extensive empire, which had gradually given way before the encroaching power of the Romans, was finally overthrown by that people, and the earliest school of art established in Italy was destroyed, 480 years subsequent to the building of Rome.

As early as the thirteenth century, in the republican cities of Italy, the love and practice of the fine arts had been advancing with the progress and sense of freedom. The Tuscan spirit of elegance, relieved from the imperial chain which had so long enthralled it, had begun to revive; and, towards the close of that century, Pisa, with other neighbouring cities of the old Etruria,—its ancient seats,—were already, once more, distinguished for art. The founder of this new school (the first of restored sculpture in Italy), or, at least, the sculptor by whose name it is earliest

illustrated, was Nicolo Pisano; and it may be observed, for another proof of the influence of Greek art upon every subsequent school, that he and his successors formed their taste, and modelled their style, after the spoils of ancient art which the Pisans had brought from Sicily and Greece. From Pisa, the principles and precepts of Nicolo were carried to Florence, by his grandson and pupil, Andrea: and in this city,—the future Athens of restored art,—about the middle of the next century, was erected the first academy of design, from whose bosom issued forth sculptors who spread the practice of the art over the whole of Italy, and even made their way into France, Germany, and, as we shall have occasion hereafter to mention more particularly, England itself. The unparalleled rapidity with which it extended itself, within a period (from its first revival to its final triumph in the fifteenth century) so short, marks the difference between an already perfected art, re-awakened by a crowd of propitious circumstances from the slumber of ages, and the slow and laborious march of the same art, from infancy to its similar state of maturity, in its native Greece. It is less our business, in a limited sketch like this, to point out the train of moral causes which aroused and bore onward the spirit of intelligence, in every form of its manifestation, than to record their results in that one which is our subject. But we may just mention, as one of the accidental, aiding the moral, influences, that, about this time, or shortly afterwards, many of the finest fragments of ancient art were recovered from the oblivion in which they had lain from the days of the barbarian or religious icono-clastes. An enumeration was made in the year 1430, by desire of Eugenius IV., of all the remains of former magnificence then existing in Rome, and amongst them were found only five statues,—which may give some notion of the number subsequently restored from the bowels of the earth, or dug out of ruins. The Laocoon was discovered in the year 1506. Amongst the names of those whom we find contributing to the progress of art, from John Pisano (the son of Nicolo) to Michael Angelo, we may mention

the illustrious ones of Brunelleschi and Ghiberti (to the latter of whom it is indebted for the magnificent bronze gates of the baptistry, at Florence, one of the finest works of all modern art, and to which has been given, from an enthusiastic expression of Buonarotti's, the title of the "Gates of Paradise"), the far greater one of Donatello (the most illustrious of all the Italian predecessors of the mighty Florentine, second, in the whole history of that era of revived art, to him alone,—and of whom it was said, in reference to the Pythagorean doctrine of transmigration, that "either Michael Angelo's soul energized in his body, or his in Michael Angelo's"), and that of Dominic Ghirlandaio, less for the sake of his own genius (which was displayed more in painting than in sculpture) than because he was the master of Buonarotti, and shares with Bertoldo, a pupil of Donatello, the proud distinction of being the source from whence that matchless artist derived such portion of his art as was not direct inspiration.

It is impossible not to be struck, at once, by the resemblance which the period immediately antecedent to the labours of the great Florentine bears, morally and politically, to that which preceded the advent of Phidias, —by the identical condition at which the art itself had arrived, in each case,—and by the similar style adopted by the two great masters—that of the Grand, as contrasted with that of the Beautiful, practised by an illustrious successor of each, Praxiteles and Canova. In each case, the spirit of freedom had evoked a host of intelligences; long strides had been made in moral, intellectual, and political knowledge; miracles of poetry had been achieved; and the Pericles of the one period has his parallel in the Medici of the other. In each case, too, the art, as regarded the mere forms of imitation, had attained perfection; and awaited but the coming of a master-mind to invest those forms with a living intelligence, and animate them with the spirit of immortality.

The long and crowded annals of the fine arts have charge of no reputation more vast and indestructible than that of Michael Angelo; but his crown is composed of a wreath culled from each of their three fields. —Sculptor, painter, architect,—the energy which he infused into, and the influence which he exercised over, each of these departments,—together with the fact that, in each, his genius was exercised upon, and has left perfected, the most sublime memorials ever undertaken in honour of our own religion,—have gained for him a name surpassing every other name in art, and not to be pronounced without a feeling of solemn veneration. The sublimity and originality of his genius, as well as the unprecedented range of his powers—his profound scientific attainments, and bold anatomical displays; the elaborate complication and wonderful grandeur of his grouping; the unequalled rapidity and novel character of his execution; and the lofty and daring subjects to whose achievements he bent this unrivalled combination of great and singular qualities—have separated and set him apart from all other artists, and placed him, as regards comparative criticism, in a category by himself. No name can be found to place by the side of his who built the Cupola, sculptured the Moses, and painted the Last Judgment,—a work which, taken in connection with the paintings on the ceiling of the Sistine chapel, with which it forms one great whole, has no competitor, for vastness and sublimity, in any production of art, throughout the whole extent of its history, in ancient or modern times. True it is, that the noblest efforts of this overwhelming genius are those which he executed in colours. As a sculptor alone, and merely judged of by the works of that kind which he has left, we should, in many of the qualities which unite to form the perfection of that art, according to the recognized canons, be compelled to assign him a place below that of Phidias;—although no work of sculpture, ancient or modern, approaches the Moses in point of grandeur. But it is a troubled grandeur—distinct from the sweet and solemn majesty of ancient and perfected art. In fact,

the severe and simple rules which long experience and enlightened study had pointed out and established, as best adapted to the limited resources and uniform materials of the ancient and dignified art of sculpture, were of too cold and passionless a character to suit the fiery temperament of this wild and winged genius; and the grand and daring effects which his fervent imagination sought, were to be reached at the expense of any particular canon which might restrain him in their attainment. The result of all this has been, that he has left behind him works which are amongst the miracles of genius; and that startle the mind into an admiration that leaves it but little inclination to question the legitimacy of the means by which they were produced, or to contend for the unvarying application of the principles, in whose absence results so great and impressive have been achieved. But, at the same time, by setting at nought the safe and confirmed rules of pure and established practice, and teaching (by his own bright and dazzling example) inferior spirits to venture upon the adoption of conventional and fantastical modes in their place (as in the case of his Neapolitan successor, Bernini), he prepared the way for the rapid deterioration, and final and certain extinction, in other hands, of that art which in the meantime, and in his own, he carried to the highest reach of the sublime; and left the gigantic monuments of his own mind, towering along the edge of that gulf in art which he had himself dug to furnish forth their materials.

As the most striking example of these marvellous works, let us return to the Moses, sculptured by Michael Angelo for the tomb of Pope Julius the second,—a monument which, had it been executed after the sketch furnished by that artist, would have been the most magnificent work of sculpture which modern times have produced; but whose composition was afterwards reduced to one-fourth of the original design, and whose figures were executed by inferior sculptors, with the single and stupendous exception

of the Moses itself. About this wonderful statue there is a sublimity not to be penetrated. It cannot be looked at steadily. We involuntarily think of Moses, as he came down from the mount. We feel that we are gazing on one invested with a portion of the awful attributes of the dread Being with whom he is permitted to converse; and cannot, for an instant, think of him as of a man fashioned like unto, and having sympathies with, ourselves. The idea is present of something beyond a human leader or law-giver. The figure seems filled and expanded with the inspiration of prophecy. His nature seems to have grown beyond mortality beneath the influence of its awful communications. No mortal hand had dared to try such a subject but his own; and no other hand of mortal could have succeeded. It is to be remembered that the gods whom the heathens sculptured were the subjects of a somewhat familiar intercourse with mankind; and invested with none of those unimaginable attributes which forbid all approach, even in thought. The Jupiter, at Elis, as a work of mere power,—as an effort of the imagination,—will admit of no comparison with the Moses. For effect produced, the world has nothing like it. The sculptor must have been in a state of mind, when he worked upon it, too highly excited to think about the canons of his art,—or care for them, if he had. True it is, that the superhuman effect is obtained by means, though different, yet strictly as far from being in accordance with those rigid canons, as are the golden hair and jewelled eyes of the Elian Jove. Yet, scarcely to preserve those rules from utter oblivion,—and, certainly, not for the sake of securing their application in the case before us,— would the world consent to part with this great and matchless monument.

But we must not delay ourselves over an examination or description of works so well known as those of Michael Angelo. The productions of his chisel are few in number, and for the most part unfinished; for his unwearied industry exhibited itself in the multitude and variety of the

conceptions which it was called on to express, while his restless and creative spirit would not pause upon the slow labour of perfecting its own rapid designs. Amongst the finest of his sculptured works are the recumbent figures expressive of Daybreak and Night, in the monument of Julian di Medici, in the Medici Chapel, at Florence; and the group of the Madonna, with the dead Christ on her knees, in St. Peter's, at Rome.

With the name of Michael Angelo our task, in these introductory remarks, is drawing to a close. His death was followed by the rapid decay of the last great school of sculpture, previous to those of the age which had its direct influence on the American school. Over the expiring efforts of that school our limits do not permit—nor does their dignity require—that we should pause. It is little to be wondered at, that a mind of so overpowering an order should have left its impression on the greatest part of the century which followed him; and that every sculptor for the fifty years succeeding his death should be a copyist of his style. Accordingly, we find that style, within a very short period after his decease, extended by his scholars and imitators into the various cities of Italy; and transported into France by Rustici, the master of Leonardo da Vinci, and by John of Bologna, the most eminent of all the pupils of Buonarotti, and the sculptor who, after his death, became the leading master of his art in Europe. Among the most distinguished of the contemporaries and survivors of Michael Angelo, must be mentioned the name of Bandinelli; and having found room for that of Benvenuto Cellini, who united the professions of a goldsmith and sculptor in metals, we must take leave of the Florentine school, which gradually languished, and, towards the beginning of the seventeenth century, finally became extinct.

After the decay of the great school of Tuscany, from a crowd of obscure names we single the more illustrious one of Bernini (to which we

have already alluded), who, with great talent and wonderful fancy, departed
from all the rules of severe and simple taste, which had been established
as the standards of excellence in his art, in an attempt to imitate Michael
Angelo, by the introduction of a school of his own; and having been
originally himself a painter, threw away the high fame which he had all
the qualities, except judgment, for attaining, by an absurd and impracticable
endeavour to embody, in sculpture, the style of Correggio's painting. His
followers were Rusconi, Algardi, Moco, &c.; and, in their hands, the art
continued to deteriorate and decay; till, finally, for want of that encourage-
ment which it had ceased to deserve, it fell into a lethargy during great
part of the eighteenth century; from whence it was only to be re-awakened
by a mind wise enough to go back to the first principles of nature,—
instructed enough to bring into comparison with, and test by them, the
various principles which had been offered as the standards of art,—and
with taste and judgment sufficient to aid him in his selection from both.
And such a one the close of the eighteenth century produced in—Canova.

But, at this point, our task of tracing the progress of the art down to
the time at which its past history exerts an influence on the American
sculptors terminates, and with a rapid sketch of the little that had been
done in sculpture in the other countries of continental Europe down to the
formation of their modern schools, and a hasty review of its progress in
England to the same period, we must bring these introductory remarks
to a close.

In France, from its proximity to Italy, as well as from the intercourse
maintained between its early kings and the Greek emperors, a taste for
fine art had at all times been kept alive. In the reign of Francis I., a
school, similar to the improved one of Italy, was founded by Leonardo da
Vinci, Benvenuto Cellini, and Primaticcio. The native sculptors of eminence

whom it shortly produced were Goujon, Pilon, and Cousin,—the first of whom executed the works on the Fountain of the Innocents, at Paris. Jacques D'Angouleme was contemporary with Michael Angelo. Towards the close of the sixteenth century, John of Bologna, as we have already mentioned, established the principles of his great master in France; and Girardon and Puget perpetuated them to the age of Louis XIV. Sarasin, one of the most distinguished sculptors of France, executed the Caryatides of the Louvre; and from this time, down to the Revolution, we have the names of Les Gros, Theodon, Le Peintre, Desjardins, Vaucleve, Couston, Bouchardon, and Pigal.

In Germany, before the seventeenth century, we find no sculptors worthy of the name, and no works deserving of notice. Subsequent to that period, we have the names of Rauchmüller, in Vienna; Leigebe, in Silesia; Millich, Barthel, and others, at Berlin; and Alexander Collins, at Mechlin,—whose monument of the Emperor Maximilian, in the Church of St. Anthony, presents a striking and magnificent example of sepulchral sculpture. In that country a modern school of art has latterly arisen, which bids fair to extend its reputation in the department of sculpture, and has already produced works which will suffer little by comparison anywhere, in immediate connection with all but the *best* of modern times.

In Spain, as in France, the art of sculpture was derived from Italy. Their great sculptor, Paul de Cespides, issued from a school of art established in that country by a pupil of Michael Angelo.

England is rich in examples of ancient sculpture from a very early period; but wearing, for the most part, traces of a foreign origin, and having the impression to that effect—which is derived from the works themselves—frequently confirmed by such evidence as exists. A minute

and critical inquiry into the abundant and interesting remains of this art, which embellish the cathedrals and churches of England, would be out of place and proportion in this general view of sculpture,—in which that of Britain, up to a recent period, forms but an unimportant, and not very distinct or original episode. For particulars of great interest connected with these old English sculptures, we refer our readers to the view of that subject taken by Professor Flaxman, in his lecture delivered from the chair of the Royal Academy; and for examples of the same, to the valuable publications of Mr. Britton. For ourselves, we must skim over the surface to a conclusion.

What kind of native sculpture may have existed amongst the early Britons, if any, there are no remains to show; the remotest examples of this art that have come down to us being (according to Flaxman) some rude coins, apparently imitations of the Tyrian or Carthaginian, with which countries they had commercial intercourse. That they subsequently imitated the arts which they had learnt from their Roman conquerors, there is abundant evidence to prove, both from the works of historians, and from a vast body of remains discovered in various parts of the kingdom,—notwithstanding the general destruction of the vestiges of Roman grandeur by the Saxons who succeeded them. What traces still remain of the architecture and sculpture of these Saxons themselves are, however, rude and barbarous imitations of the very works which they destroyed; and the same are also imitated in the Norman productions, but with more skill. It was immediately after the Norman conquest that figures of the deceased were first carved in bas-relief on their gravestones, examples of which remain in Westminster Abbey and Worcester Cathedral. From the return of the Crusaders down to the age of Henry III., sculpture increased in popularity and consequent excellence; and the reign of that monarch exhibited examples not undeserving of praise even in the present day,—allowance

being made for the imperfect lights under which they were produced. An instance of this may be found in Wells Cathedral, which Bishop Joceline rebuilt before the middle of the thirteenth century. The magnificent stone crosses erected, in the reign of Edward I., on the spots where the body of his queen, Eleanor, rested on its journey to its tomb in Westminster Abbey (and of which three still remain), and the tomb and statue of Henry III., in the same place (together with many other works of this, or later date), bear evident traits of the school of Pisano; and are generally supposed to have been executed by some of those numerous travelling scholars, whom we have already mentioned as having spread the principles of that school over the whole of Italy, and finally extended their wanderings and labours over the west of Europe, until they reached Great Britain. In the reign of Edward III., the encouragement given to the arts was general; and the richness, novelty, and beauty of the sculptures of that day may be seen in York and Gloucester Cathedrals, as well as in many other churches and monuments. There is reason to believe, however, that these also were the work of Italians. But it is said that the artists employed by Edward III., in his collegiate church of St. Stephen (now the House of Commons), were for the most part Englishmen. The tomb of Henry VII., in the Lady Chapel of Westminster Abbey, is the work of Torrigiano, an Italian; but Flaxman is of opinion—from a variety of interesting circumstances relating to it, which are mentioned by Britton, in his Architectural Antiquities, and from other evidence—that Torrigiano was concerned in the tomb and statues alone, and not in the building which contains them, or the remaining statues with which it is embellished. The chapel and its sculptures, he thinks, were probably native productions. Henry VIII., in the early part of his reign, had for his Master of Works an Italian, John of Padua, a scholar of Michael Angelo; but, towards the close of his reign, and throughout that of Edward VI., the iconoclastic spirit was let loose in England, and many of the noblest and most

magnificent efforts of British art perished. It is probably owing only to their great number, which baffled the destroyer, that so many of them are still left to the present day. This spirit of destruction continued to rage, with more or less violence, down to the period of the civil wars; when its furious orgies desecrated most of the temples in the island, and finally extinguished the genius of liberal art amongst her sons. When, therefore, on the Restoration, the ravages of this demon of devastation had to be replaced, she was compelled again to visit the land of the foreigner for that proficiency in art which her own soil could not furnish. During this abasement of native sculpture, we find the names of three Englishmen— Christmas, Stone, and Bird; but their labours only tend to make conspicuous the wretched condition to which the art was reduced. Steevens, De Vere, Caius Cibber (the sculptor of the Kings at the old Royal Exchange, the bas-relief on the Monument of London, and the celebrated figures of Melancholy and Madness in the Hall of Bedlam), Scheemacher, Roubiliac, Carlini, Locatelli, Rysbrack,—nearly all the sculptors, in fact, who flourished in England during the greater part of the eighteenth century,—were foreigners.

Thus, not until towards the conclusion of the last century, can there properly be said to have existed a school of British Sculpture; and she, like the rest of Europe, was indebted—both under the emperors, and at the period of the restored arts—for the treasures of that kind with which she is enriched, to Greek art, passing through Roman hands, and modified by Roman forms. The British school may be considered as commencing with Banks (for Wilton was educated abroad), whose works have eclipsed nearly all his continental contemporaries, as they have since been far surpassed. We have had occasion to notice that, in many countries of Europe besides Italy, there is just now an awakened and improving spirit in this walk of art, which promises well for the extension and

perpetuation of right principles; and, in our enumeration, Denmark must not be omitted, for the sake of her great son Thorwaldsen, although he was an adopted citizen of Rome.

The rapid sketch, which we must now close, has brought down the history of the art, in a general and cursory way on all sides, to the time of the American school of sculpture, with a view to whose promotion, and to make the public better acquainted with which, these illustrations have been undertaken. We are anxious that the publication and encouragement of modern, and above all of native art, should, at least, be concurrent and co-extensive with the publication and encouragement bestowed upon that of the ancient and the foreigner; and that the general public should have an acquaintance with the beautiful specimens of sculpture which enrich and exalt our own day and land, at least equal to their knowledge of those immortal works which they replace, or by the side of which, in many cases, they may boldly challenge to stand. A school of sculpture has at length, as we have observed, and with almost unexampled rapidity, grown up in America,—based upon the purest principles of the best days of Grecian art, and in harmony with the feelings and habits of our land. In the service of religion this art never was used amongst us, from a feeling (whether right or wrong) that such application of its resources savours of idolatry, or may lead to it; or, perhaps, from a belief (which is certainly right) that subjects of that nature are of too sacred a character for a mode of illustration so palpable and substantial as sculpture. But, in the service of the tomb—in the embellishment of our homes—in the illustration of our affections—in the perpetuation of what is great and tutelary amongst us—it has assumed an aspect and a tone well suited to add to the sources of our intellectual enjoyment at home, and to elevate the national character abroad. Sculptors have arisen amongst ourselves, and in our own day, second only to the very greatest masters of

the art in all time; and works have been produced, in its various kinds, which we dare almost place beside their best in the same. At the present moment, no school of sculpture in Europe can claim to take the lead of that of America; or promises, with due encouragement to this latter, so fair for progressive excellence. Once more, then, we call upon that part of the public to whom the elegant and intellectual arts are a solace and a joy,—again we demand of their wealthy patrons to extend the cheering influence of their encouragement, in every mode of its exhibition which may be in their power, to the sculptures of their native land; to do what in them severally lies for the promotion of an art adapted, in a language so delightful, to enforce the lessons of wisdom and virtue, and embalm and utter the records of the heart.

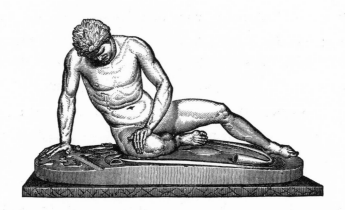

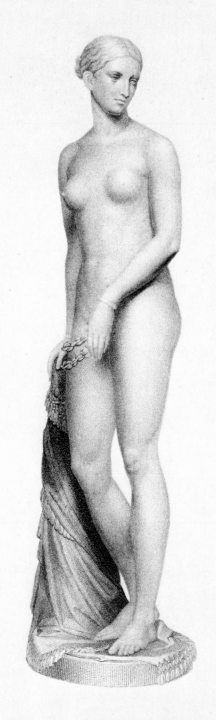

THE 'GREEK SLAVE.

ENGRAVED BY W ROFFE FROM THE STATUE.

IN MARBLE BY HIRAM POWERS.

CHAPTER II.

POWERS AND GREENOUGH

HIRAM POWERS was the first American sculptor who achieved a European reputation, and a European reputation in 1843, when he finished his Greek Slave, meant much more for an American than it means to-day. We have not yet got beyond the time when the cordial endorsement of Paris or London is worth very much to an American artist or author, but we certainly have got beyond the time when such endorsement is necessary in order to obtain for an American artist or author the cordial appreciation, hearty commendation and liberal patronage of his own countrymen. It was the special good fortune of Mr. Powers that, at a most opportune moment, he was able to rivet the attention of European, and particularly of English connoisseurs, with a purely ideal work, full of grace, tenderness and pathos, which was in every way worthy of himself and of his country. The Greek Slave opened the eyes of European art lovers and art critics to the fact that there was a rising school of American sculptors, which asked nothing of Europe except the instruction which its great galleries, filled with the fragmentary remains of antique art, alone could give, and which yielded nothing to modern European art in invention, ideality or technical skill.

45

Powers' Greek Slave was completed at a fortunate time. The woes of the Greeks and the liberation of Greece from the Turkish yoke were subjects concerning which enlightened people, both in Europe and America, thought deeply—and no theme that the young American sculptor might have chosen for his first important ideal work could have so touched popular sympathies as the singularly happy one he did choose. He addressed a public that was ready to admire and to praise, and that did admire and praise without stint. The Greek Slave was a famous statue before the opening of the great International Exhibition of 1851 in London; at that exhibition it was the one work of art by an American that did credit to America. To say that it well held its own with the contributions of European sculptors, would be to do it scant justice. In some of the highest artistic qualities it was not surpassed by any piece of sculpture in the Exhibition, while in many other high qualities it surpassed any of them. The critics praised it and accepted it as a promise of greater things to come, not only from the same hand, but from the hands of Mr. Powers' countrymen; English wealth gave appreciation a substantial value to the artist by purchasing it; the English public admired it and frankly said that it did; and the greatest of English female poets wrote a sonnet on it. When Mrs. Browning sincerely and heartily admired anything it was not her custom to express her admiration in vain and halting words. There was that in Hiram Powers' Greek slave which touched her deeper than her mere artistic sympathies. Gazing at this statue, her thoughts flew from Greece to the native land of the artist, and the marble chains on those fair marble hands seemed to be a reproach on the artist's countrymen. She felt that Mr. Powers had given her his best, and had also given her an opportunity to do a little preaching, and so she gave him her best in the shape of the following sonnet—a sonnet which no poet but Mrs. Browning could have written:—

"They say Ideal beauty cannot enter
The house of anguish. On the threshold stands
An alien Image, with enshackled hands,
Called the Greek Slave! as if the artist meant her
(That passionless perfection which he lent her,
Shadowed, not darkened, where the sill expands)
To so confront man's crimes, in different lands,
With man's ideal sense. Pierce to the centre,
Art's fiery-finger!—and break up ere long
The serfdom of this world! appeal, fair stone,
From God's pure heights of beauty against man's wrong!
Catch up in thy divine face, not alone
East griefs, but West,—and strike and shame the strong,
By thunders of white silence overthrown."

The strong genius of Mrs. Browning was in one of its greatly grotesque moods when she wrote that. "Thunders of white silence"—what a figure! It ought to have been worth more to the heart and brain of Powers than all of the applause of the populace, or than all of the gold which his statue brought him.

The Greek Slave was Powers' first ideal work, or at least the first with which he was willing to make an appeal for recognition to the public. Whether the fame which it won for him cramped his genius instead of expanding it, it is impossible to say, but it is certain that he never surpassed, and never equalled it by any subsequent performance. His California, his Fisher Boy, his Eve Disconsolate, and his Last of the Tribe are all works of considerable excellence, but they are all inferior to the Greek Slave in that nameless something which raises a work of art far above the level of the commonplace. The Greek Slave was sculptured nearly half a century ago, and it now more than justifies its original reputation, when placed in comparison with the many ideal statues that

have been made by men who have risen to fame since Powers startled Europe and America with this masterpiece. Not long ago we saw the replica of this statue which was purchased many years ago by Mr. W. W. Corcoran, and which is now in the Corcoran Art Gallery in Washington, and early impressions of it were fully confirmed. There was, it is true, feeble modelling in parts, indicative of crude and imperfect training, and of a lack of knowledge on the artist's part of some of the refinement of the human form; but after all deductions were made, the purity, expressiveness, and truly ideal grace of the statue remained to testify that the one-time enthusiastic admiration of Europe and America was not misapplied or wasted on a mere piece of artistic trumpery.

It has been claimed for Powers by some of the least judicious of his admirers, that, when he went to Italy, his ideas were fixed, and too firmly fixed, for him to be influenced in any material degree by the great works of the classic and renaissance periods which he found there, and which, for the first time, he was afforded an opportunity of studying. It has also been claimed that in nature, rather than in classic art, did he obtain the inspiration for his ideal statues. These claims are distinctly unfounded, and they have certainly been made on the strength of the artist's pretensions, rather than on the strength of a critical study of his performances. Powers was quite in the habit of speaking in a very dogmatic way concerning himself, his work and his theories, and as he undoubtedly believed all that he said, it is not to be wondered at, perhaps, that he should have persuaded others to coincide with him in his beliefs. Powers, however, when he went to Italy had absolutely no art training worth speaking of—for the wax-works and the few busts which he modelled before crossing the ocean, can scarcely be considered as having initiated him into the mysteries of the alphabet of his art. He was profoundly ignorant of

the human figure as a whole at the outset of his artistic career, and although he used living models in his studio, he certainly gained most of his knowledge of the figure from a study of the antiques. It was most creditable to him, that, with his very imperfect training, he was able to accomplish what he did, and to claim for him more than he was entitled to, is to injure, rather than to advance his fame. His full length figures are lacking in just those very qualities that would certainly mark them, had the artist been a close, careful and thorough student of nature, while they are marked by the very qualities that will always be found in the works of a man of real talent who bases his study on the antique. When the Greek Slave was first exhibited there were, of course, plenty of disparagements uttered against it. The most important of these—or what would have been the most important, had there been any truth in it—was that it was a mere imitation of the Venus de Medicis. Except in the matter of the position of one of the hands of the Greek Slave, there was no foundation whatever for this accusation; and when we call to mind that the arms of the Venus de Medicis are modern restorations, and are so palpably inferior to the antique portions of the statue that no artist of judgment and taste would think of copying them, the accusation is reduced to an absurdity. Not only are the motives of the two statues totally different, but, except that they both represent young and beautiful women, and that they are both idealizations of the female form, they have no essential points of resemblance. It is nevertheless true that the Greek Slave is an idealization in the classic rather than in the renaissance or modern sense. For its exemplars we must look to the remains of Greek art, and not to nature or the performances of artists of the modern school, of which Michael Angelo was the father. While this statue, however, is undoubtedly an attempt in the classic style —whether Powers intended it to be so or not—it is exceedingly interesting to note that the head is unmistakably American in its type. Consciously or unconsciously Powers refused to go to either ancient or modern Greece

for the head of his ideal Greek Slave, but chose a type with which he was much more abundantly familiar.

The production of The Greek Slave marked the turning-point of Powers' fortunes. That statue brought him not only fame, but, what was of quite as much importance to a struggling artist in a foreign land, pecuniary independence, if not wealth. Orders poured in upon him, and in a comparatively short space of time he was able to charge his own prices, and to decline work for which he had no inclination. It became the fashion with wealthy Europeans and Americans to have their busts done by Powers, and the number of works of this class which were turned out from his studio must have been enormous. It is undoubtedly upon his busts that his fame as a sculptor will chiefly rest. As has been before stated, he never surpassed nor equalled the Greek Slave in any ideal figure —full-length figure, we mean, for his bust of Proserpine is a very charming work, which is quite up to the standard of the Greek Slave—but some of his portrait busts are masterly, and have probably been surpassed by few similar performances of later American sculptors.

In referring to Powers as the first American sculptor who was successful in gaining a European reputation, it would be unjust to the memory and fame of a man to whom he undoubtedly owed much, and who was an artist of broader views, more liberal culture, and finer genius, to leave the impression on the mind of the reader that he ought to be considered as the father of the American school of sculpture. To Horatio Greenough, who had been residing for some time in Italy when Powers went there, Powers was indebted for a great deal more than the mere sympathies, advice and social courtesies, which one American artist of high attainment, and a large-heartedness of disposition that harbored no thought of any but the most honourable rivalry, would naturally extend to a fellow-

countryman on meeting him in a strange land. Greenough, when Powers made his acquaintance, if he did not have the thorough training as an artist which it is considered indispensable that an artist in our day should have, at least did have some training—and that very good of its kind—while Powers, beyond a moderate amount of skill in manipulating clay and wax, had absolutely none at all that was of any real value to him. There can be no doubt that Greenough's assistance in directing his studies, and in correcting his work, was of the greatest value to Powers, and that the kindly interest which Greenough took in him and his affairs had a most potent influence in shaping his future career, and in promoting his pecuniary as well as his financial success. Greenough, if less fortunate than Powers in achieving a European reputation at a time when a European reputation was particularly well worth having, was more fortunate than he in obtaining from the United States government two very important commissions. He was especially fortunate in this, for, while most of Powers' works are hidden from the public in private collections, and are only known through the medium of engravings and photographs, Greenough's master-pieces belong to the nation, and are so placed that it is possible for every one to study and enjoy them. These two works are the statue of Washington, in the open space facing the east front of the National Capitol, and the imposing group entitled The Rescue which is one of the adornments of the east front of that noble building.

The fame of these two exceedingly fine performances is increasing with the increase of artistic culture in the United States, but it is a fact, that they never have as yet been appreciated in accordance with their great deserts by the mass of the artist's countrymen. For many years, indeed, the Washington was an object of ridicule by the ignorant and unthinking, who were incapable of understanding the poetical aim of the artist, and we presume that the people who undertake to show strangers the "sights"

of the city of Washington are still, as they were many years ago, in the habit of cracking a very ancient and a very poor joke about the Father of his Country playing ball with the Columbus of Persico's group of Columbus balancing the World, which is at the head of the steps, on the south side, leading up to the eastern main entrance of the Capitol— Greenough's group of The Rescue being on the north side. Despite the ridicule that has been abundantly heaped upon it, and despite the jestings of small wits with regard to it, Greenough's Washington is the grandest and greatest piece of sculpture that has been executed by an American artist—just as the group of The Rescue is grander and greater than any- thing in its particular way that has come from the hand of any American. When we say of a modern statue that it is a great work of art, we necessarily put it in comparison with the world's masterpieces, and tried by this severe test, it may be that Greenough's Washington cannot with propriety be called great. Compared with the best that Greenough's contemporaries and successors have been able to do, it assuredly is great in all that goes to the making up of the illustration in marble of an ideal and poetical theme. In this statue the artist has attempted something more than a portrait, or even an ideal portrait, of Washington. He has sought to represent Washington in the character of the Father of his Country, as the guardian genius of the nation which he founded; and if we can bring ourselves to view the statue from his stand-point, it will be found to have infinitely more meaning than Crawford's Liberty, which surmounts the towering dome of the Capitol, or any of the thousand and one attempts that are being made day after day and year after year to embody abstract ideas in bronze or marble.

That Greenough's Washington has not made a more profound impres- sion on all classes of Americans—uncultivated as well as cultivated—is due in a great measure, we think, to the most unfortunate position in

which it is placed. Greenough intended the statue to stand in the rotunda of the Capitol, just under the centre of the dome, and as that is so obviously the right place for it, it is marvellous it was ever put where it is, or that it has been permitted to remain where it is for so many years without any attempt whatever having been made to give it a housing in its proper shrine. When the artist heard that it had been dumped—dumped is the only right word in such a connection—into the shabby little park to the east of the Capitol, he was horrified and grieved beyond measure. He declared that it would be impossible for the figure to produce the effect he desired and intended in such a location, or in any open air location; that in a few years, through the influence of frosts and heat, rain and sunshine, the marble would in all probability be injured beyond repair; and that, had he proposed to sculpture an open air figure, he would certainly have represented Washington on horseback, and in his uniform, as the generalissimo of the Continental armies—that is, he would have represented him as a reality rather than as an ideality. What Greenough had to say about the unfortunate placing of the noble work upon which he expended so much thought and labour is particularly worthy of attention, as it abundantly proves that, in making this statue what it is, he worked with the intelligence of a true and really cultivated artist, and that he was not carried away and induced to perpetrate an artistic absurdity by any pseudo-classical notions or theories.

A mere glance at this statue makes it evident that the artist had in his mind the descriptions that have come down to us of the famous chryselephantine statue of Jupiter by Phidias, which was undoubtedly the greatest piece of sculpture ever executed. The pose and the arrangement of the draperies are almost, if not quite the same, and even the details of the ornamentation of the chair suggest the accessories of the crowning effort of the sculptor's art. Had the statue of Phidias, or even an

authentic figurement of it, been in existence Greenough probably would have hesitated about attempting an imitation of it in his Washington. Having, however, nothing but the descriptions he probably thought himself justified in at least borrowing a suggestion from Phidias for a work totally different in idea and aim from that of the Athenian sculptor—for the Washington of Greenough is not a Jupiter, nor was it intended to be, but it is an idealization of the real Washington with a view of representing him as the guardian genius of his country. It was a bold attempt this, to even suggest an intention of imitating the Olympian Jupiter, but the boldness of the artist had its ample justification in the admirable result which he achieved. The Washington of the Capitol, if it is, as it should be, viewed as an ideal work, is satisfying—how much more than that can be said of any but a very few of the artistic masterpieces which the world contains at the present time?

Greenough has represented Washington as seated in an arm chair, severe in its outline, but richly ornate in its details. The figure is nude to the waist, but the lower limbs are clothed in a drapery which falls in ample yet graceful folds. The left hand rests on the lap and holds a sheathed sword of antique pattern; the right hand is raised and points to heaven. The countenance is full of dignity and benignity. It has all, and more of that nobility and grandeur which are revealed to us in the best portraits of Washington,—and there is both nobility and grandeur in them. The torso, which is modelled with remarkable boldness, united with refinement, is fit to be that of a Jupiter, or better still, of the idealized representation of a great nation's greatest hero, a true father of his country. Greenough said that he intended to symbolize by the peculiar attitude of the figure, the resignation by Washington of his commission, and his recommendation of his countrymen to the care and guidance of God. This explanation is as good as any, but in this as in every truly ideal

work of art, there is much more suggested than the artist was willing, or perhaps able, to put into words concerning it. The chair in which the figure is seated is beautifully and most appropriately ornamented, although not in such a manner as to attract the eye in preference to the statue itself. The chair, as an essential but subordinate part of the composition, has been kept in strict subordination to the main incident, and nowhere more than in the management of it, in all its details, have the refined taste and true artistic skill of the sculpture shown themselves to better advantage, or in a manner more instructive to those who desire to study the masterpieces of art with a view to something beyond the mere transient delight of the eye. The back of the chair is of open work, very rich but very chaste in its antique suggestiveness. One end of the back is supported by a small figure of Columbus intently gazing at a globe which he holds in one of his hands; the other end is supported by the figure of an Indian chief. Both of these statuettes are exquisitely carved, as are the bas-reliefs on the sides of the chair, one of which represents the infant Hercules strangling the serpent, and the other Apollo guiding the chariot of the Sun. The whole is cut from a single block of the finest marble that the famous quarries of Carrara were able to afford to the sculptor, and the composition in all its parts is finished with a refinement of skill that does not admit of fault-finding. Greenough fully appreciated the great honor done him when the commission for this statue was given, and he determined that through no lack of effort on his part should it be less than a masterpiece.

A masterpiece it assuredly is, and it is a thousand pities that it has not long ere this been taken in from the exposed and most unsuitable location where some blundering official dumped it, and put where it was originally intended to go, in the centre of the rotunda. What the artist feared with regard to the effects of the weather has already been to some

extent realized. The statue has been damaged, but, as yet not irreparably, but it undoubtedly will be damaged beyond repair before many years go by if it is permitted to remain unhoused. As this is by all odds the finest work of art that the government possesses, and, as the entire nation has an interest not only in its preservation, but in having the intentions of the artist with regard to it carried out, it is much to be hoped that a very serious effort will be made, and made soon, to persuade the proper authorities to take it into the Capitol building, and to give peace to Greenough's ghost by standing it where it belongs, under one of the most magnificent domes that has ever been constructed.

The group to which the artist has given the name of The Rescue, and by which he intended to symbolize the forces of civilization conquering the savage, calls for fewer words of comment than do the Washington. This was the first large group of statuary executed by an American, and so fine a one has not been executed since by any American. The figures are four in number, an Indian, a brawny hunter, and a mother and her babe. The Indian, who is nude to the waist, is grasped from behind by the white man, who stays his uplifted tomahawk. He is struggling, but struggling in vain, and the issues of the conflict are not doubtful. Behind the hunter—or rather at one side—crouches the woman with the little child in her arms. The composition entirely fulfills some of the most essential conditions of a good statuary group; it tells its story distinctly, and it composes well from whatever point of view it may be surveyed.

Greenough sculptured a large number of portrait busts, ideal busts of Christ and Abel, and, in addition to those already mentioned, several statues marked by high ideal qualities—the most important of these are a Venus Victrix, an Angel Abdiel, and a Medora.

Greenough and Powers were very nearly of an age; both were born in 1805—Powers in July and Greenough in September. Their early circumstances, and their opportunities for qualifying themselves for the adequate performance of artistic work, were very different. Greenough was the son of a wealthy merchant of Boston and he received the best education that the times afforded. His associatés were cultivated people, and his whole early training was of a kind to develop his artistic instincts and faculties. He entered as a student at Harvard when only sixteen years old, and although he did not graduate, he remained in the college long enough to go out into the world benefitted by the best instruction it was able to bestow. Greenough at a very early age showed a strong artistic bent, and he was encouraged to cultivate his talents by the sympathetic advice of Washington Allston. It was probably through Allston's recommendation that he decided to go to Rome before he had completed his college course. When he arrived in Rome, he found Thorwaldsen at the head of the school of sculpture there. Under the direction of the venerable Dane he studied hard—too hard for his health, for he was finally compelled to stop work and return home to recruit. He remained in the United States for several months, and during the time modelled busts of John Quincy Adams, Chief Justice Marshall, and other personages of more or less prominence, which gave him an excellent standing as an artist with the American public. On his return to Europe he first went to Paris, where he made a bust of Lafayette, which the subject of it and his friends pronounced the best portrait of him that had ever been executed. A replica of this bust is in the collection of the Pennsylvania Academy of the Fine Arts. This work completed, Greenough returned to Italy, where he resided until 1851, when he came to the United States for the purpose of superintending the erection of his group of The Rescue. It is sad to think that the last days of this excellent artist and most estimable man were clouded by mental disease. He died at Newport, Rhode Island, in 1852.

Powers was a self-made man. He had none of the advantages which Greenough enjoyed, and was compelled from the first to make his own way. His artistic studies were prosecuted under the most disadvantageous circumstances, and the matter for wonder is, not that he did so much work of an exceedingly meritorious character, but that he did any that was capable of giving him a genuine reputation as an artist. He was born in Woodstock, Vermont, but when he was about eleven years of age his parents removed to Cincinnati, and in that place he resided until 1835, when, with the assistance of Mr. Longworth, who took a very lively interest in him, he went to Washington with the rather indefinite idea in his head that he would there find facilities for artistic training that Cincinnati lacked. When a mere boy, Powers showed an extraordinary inventive and mechanical genius, and during his residence in Cincinnati he brought this into play to earn an honest penny wherever there was one to be earned. One of his most constant employers was a Frenchman named Dorfeuille, who managed a sort of museum. For him Powers modelled a group of wax-figures, which was greatly admired by the not very critical visitors to the museum, and made a great number of ingenious mechanical contrivances. The most important of these was a spectacular affair representative of the Infernal Regions—or at least what Powers imagined them to be. In this there was an abundance of demons, skeletons, ghosts, and so forth, which moved about with the assistance of wires and springs, and which it is to be hoped exercised a salutary influence on the beholders. Powers had been about two years in the employ of the museum manager, when he, for the first time, saw a marble bust. It was a portrait of Washington by Canova, and as the artist of the Infernal Regions and the wax-work group insisted very strenuously that he could do that sort of thing, and was very anxious for a fair opportunity to try his hand, his good friend Mr. Longworth gave him the means to go to Washington. On his arrival at Washington he speedily found that

the facilities for obtaining an art education were not much greater there than they were in Cincinnati. He, however, managed to support himself for a couple of years by doing whatever he could get pay for, and was so successful with portrait busts of John Quincy Adams, Jackson, Van Buren, Webster, Calhoun, Colonel Preston, and other public men, that his friends were induced to make an effort to send him to Europe. Mr. Longworth now again came to his assistance, and it was mainly due to that gentleman and to Colonel Preston that Powers was enabled to take up his residence in Italy, and thus put himself in the way of becoming a genuine artist. Powers is described as having been at this period, a tall, thin, and decidedly "slab-sided" individual—awkward and uncouth enough in his appearance, but with a wonderfully bright and intelligent eye, and with an exceedingly energetic and "knowing" air about him. On his arrival in Italy he found Greenough already established there, and he was most fortunate in securing him for a friend. It was in 1837 that Powers took up his residence in Florence, and he made that city his home during the balance of his life. He had not been a great while in Florence before he began to gain an excellent reputation for his portrait busts. He supported himself by the execution of works of this kind, and employed his leisure in the modelling of his Greek Slave. With the brilliant success of that statue his fortunes were secured.

Powers never lost his strong mechanical bent, and he was the inventor of a great number of tools and instruments for facilitating the sculptor's work. One of these was a perforated file, which permitted the marble dust to fall through the back of the tool instead of clogging its face. It was his habit, especially during the last years of his life, to model directly in plaster instead of in clay, as is the usual custom with sculptors. His method of working has some advantages, but they are probably more than overbalanced by the disadvantages—not the least of which is that

it is difficult, if not impossible, after a piece of work has been laid out to make the slight, but often very important, changes in the pose of a head or figure which represent all the difference between grace and awkwardness. An artist's work is necessarily, to a very large extent, experimental, and no matter how thoroughly a subject may be digested in the mind, or how ample the preparations may be, only when it is tolerably well advanced is it possible to decide exactly what it shall be in all its details. This is particularly the case with a piece of sculpture, and the sculptor who deprives himself of the facilities for making changes which the soft clay affords, places himself at a very great disadvantage. That Powers' method of modelling in plaster is not the best is proven by the fact that it has not been adopted by sculptors generally. Powers, however, was an obstinate and an opinionated man, and having satisfied himself that his notions and ways of doing things were the best he did not permit himself to remain open to argument. One of his notions was that the government owed it to him to give him an important commission. He was invited to compete for some of the statuary work of the Capitol, but this invitation he resented as an insult. That he did not get an important commission was perhaps fortunate both for himself and for the government. Excellent as many of his performances were, there was nothing in the best of them to indicate that he was capable of doing full justice to such themes as he would have been compelled to treat had he undertaken to contribute to the adornments of the National Capitol.

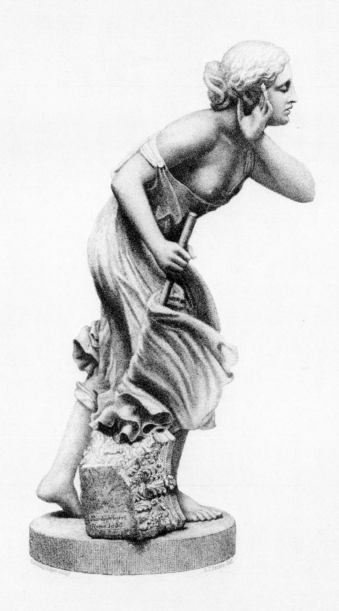

NYDIA THE BLIND GIRL OF POMPEII.

CHAPTER III.

CRAWFORD AND ROGERS

T would be impossible to bestow higher praise on any work of art than that which Michael Angelo bestowed upon the second pair of bronze doors which Ghiberti made for the baptistery of the Church of San Giovanni in Florence. He said that they were worthy to be the gates of Paradise, and he proved the sincerity of his admiration by imitating some of their details in his own still mightier works. The figure of Adam, in the painting by Michael Angelo on the ceiling of the Sistine Chapel representing the creation of our first parent,—a figure which is justly regarded as one of his most masterly representations of the human form—is identical in all essentials with a similar figure in one of the panels of Ghiberti's doors. In those days it was necessary for an artist to be a thorough workman as well as an inventor. The problem Ghiberti had before him, when he competed for the execution of these doors, was not so much the production of designs superior to any that had been made before, or than those who engaged with him in the competition were capable of, as it was the making of a perfect piece of bronze casting. In the first pair of doors, which illustrated scenes in New Testament history, he was obliged by the terms of his contract to follow the general characteristics of a pair made by Andrea

Pisano from designs furnished by Giotto. Ghiberti's composition, and the workmanship on it, were so far superior to his model, that the contract for another pair of doors, to be embellished with Old Testament scenes and subjects, was awarded to him without competition, and it was not only permitted, but desired, that he should rely upon his own genius for the invention and execution of the work in all its details. Being left entirely unfettered, the artist surpassed himself as he had previously surpassed others, and he succeeded in producing a masterpiece, the influence of which upon the revival of the art of sculpture was immediate, important and far-reaching. Herman Grimm says that this pair of doors "is the first important creation of Florentine art," which is as much as to say that it carried the renaissance beyond its mere tentative stages, and made possible the great modern works which rivalled, and, in not a few particulars, surpassed the performances of the greatest of the ancients. A cast, in plaster, from these doors has been for many years in the collection of the Pennsylvania Academy of the Fine Arts, and it has justly been regarded as one of the most valued of the treasures of that institution.

It was upon Ghiberti's design that Thomas Crawford and Randolph Rogers based their designs for the two sets of bronze doors at the National Capitol at Washington. These doors are not the less admirable for being in a certain sense imitations of an older work; on the contrary the chances are that a greater measure of success has been achieved by the frank acceptance of an acknowledged masterpiece as a model than would have been had the artist decided to attempt the execution of entire novelties. It is a characteristic of all the arts that certain types become fixed, and it is only men of the widest and most original genius who are able to break away from them and to give the world something new, which in its turn becomes a fixed type. Indeed, men of the highest genius—such men as only appear occasionally in the course of centuries—very much

oftener produce what are in reality only modifications of fixed types than they do what can properly be regarded as absolutely new creatures. Even so great and original an artist as Michael Angelo was content to adopt and improve upon the conceptions of his predecessors, and we find the prototypes of some of his most characteristic works in the figures on Ghiberti's doors, just as we find the prototypes of some of the most imposing features of Dante's Divine Comedy in numerous works dating from Homer's time to his own, or the prototypes of many of the most impressive features of Shakespeare's plays in Homer, in Boccaccio and the other Italian novelists, and in the dramatists who were his immediate predecessors and contemporaries.

The bronze doors modelled by Crawford are hung at the eastern entrance of the north, or Senate wing of the Capitol. Those modelled by Rogers are at the eastern entrance of the central building, and open into the rotunda. Both are most advantageously placed, more so in fact than many of the sculptures and paintings which are supposed to decorate the Capitol. It cannot be denied, however, that some of the so-called works of art in this building are well hidden away in dark corners, for they do credit neither to those who executed nor to the government which ordered them. It is putting it mildly to say that the money expended on them was wasted. The American people will probably some time awaken to an appreciation of the fact that they possess in their National Capitol a magnificent architectural pile, which, in many of the essentials of true grandeur is not equalled nor surpassed by any building in the world, and will demand that the genuine works of art that have been executed for its adornment shall be properly placed and properly cared for, and that Congress shall cease giving commissions to artistic charlatans for the disfigurement of its walls and niches. So utterly meretricious are many of the paintings and statues at the Capitol, and so utterly reckless

has Congress been, especially of late years, in giving very important commissions to persons whom it would be a stretch of courtesy to call artists, that it is matter for sincere congratulation that it fell to such competent sculptors as Greenough, Crawford and Rogers to design many of the most important of the artistic adornments of the building. The bronze doors of Crawford and Rogers may not be beyond criticism, and the statues by Crawford which fill the pediment of the north wing may fall far short of being all that a pediment group ought to be, but it will be fortunate if the doors which are yet to be made, and if the group for the south wing are at all up to their standard of excellence. The statues of the Italian Persico, and the queer bas-reliefs in the rotunda, we do not wonder at, even if we fail to admire them. When they were executed there were no American artists—and especially no American sculptors—capable of undertaking such works, and there was besides little artistic knowledge and little artistic taste, even among the most cultivated men of the day. The worst of these things, however, is respectable, and even worthy of admiration in comparison with the hideous fresco which disfigures the ceiling of the dome, not to mention other of the abominations,—nearly all of which are contemporary—which greet the eyes of the visitor at every turn, as he strolls through the building. For these things there is absolutely no excuse; the large sums of money that have been expended upon them have been worse than wasted; and it is discreditable, not only to Congress, but to the American people, that they should exist and that there is a strong probability of many more of the same kind being perpetrated, until the Capitol becomes a veritable house of horrors.

Crawford was an artist gifted with a prolific invention—indeed, his invention too often ran away with his judgment as a careful workman; that is, it induced him to undertake more than it was possible for him to execute in the best manner—and his artistic education was much more

complete than that of any previous American sculptor had been. He, however, attempted too much, and did too much, for the work to be thoroughly well done. Many artists, it is true, have attempted more and executed more, but it has been with the assistance of large numbers of men whose attainments were of a very high order, and who had as just a claim to be regarded as artists as the masters under whose directions they worked, and whose conceptions they aided in carrying out. Crawford had no assistance except that of the bronze founders and some Italian marble cutters, who, however skillful they might have been within the limitations of their powers were merely workmen, and were not in any proper sense of the word, artists. Ghiberti was forty years in making the two pairs of bronze doors for the baptistery at Florence, and in the making of them he had, not only the help, first of his father and then of his brother, but that of a considerable number of skilled modellers and metal workers. Nearly the whole of his artistic lifetime was spent in the execution of this one task, while Crawford's pair of doors, which are as elaborate in their general design as those of Ghiberti, constitute but a single item in a long list of sculptures designed for the United States Government, to say nothing of his many other performances. The mere making of the designs, however, important a part as it was, was not the major part of Ghiberti's task. Fine and truly original as the designs are, the astonishing thing about these doors is the exquisite finish of every detail, to the very minutest. They are jewels on an immense scale, and it is the workmanship quite as much as the designs that give them their value. Crawford's task was practically at an end when his models were completed and cast in plaster; the doors themselves were cast and finished at the bronze foundry. The modern artist too had his general design ready made for him, at least to all intents, but this was all the more reason why the details, which were his own inventions, should have in some measure approached the rare excellence of the work which he took for his model. Of the baptistery

doors it is told, not only that Michael Angelo copied from them his figure of Adam and his composition of Noah and his Sons on the ceiling of the Sistine Chapel, but that they suggested a variety of new motives, both to sculptors and painters, as, for instance, the lifting of the shoulder by the weight of the body being pressed upon one arm. Rich and really beautiful as Crawford's work certainly is, we look to it in vain either for suggestive details of this kind or for the jewel-like finish of the doors made by Ghiberti.

In calling attention to the comparative shortcomings of the bronze doors of the Capitol, there is no disposition to judge harshly the works of the artists—for what has been said concerning the pair of doors designed by Crawford, will apply with equal or greater force to the pair designed by Rogers—but, is it not worth considering whether the reason why these and so many other modern artistic performances of quite genuine merit, in certain respects, fail to impress in an adequate manner, not merely the masses, but cultivated beholders, is that they are lacking at once in thoroughly refined workmanship, and in other and equally essential matters? There is this, however, to be said in behalf of the modern artists—they were limited both in time and money, while Ghiberti, especially for his masterpiece, was given an absolute *carte blanche*. The Italian, too, was sustained and stimulated by a popular interest in his work and by an assurance of hearty popular applause, while the Americans had only a few cultivated people among their countrymen to take any interest whatever in what they were doing.

The pair of doors designed by Crawford represents the civic and military careers of Washington—the scenes in the panels of one wing being important incidents of the period when he fought to give his country liberty, and those in the other being records of his services as a statesman

in aiding to establish those liberties on a firm basis of constitutional law. The composition is exceedingly rich, and, as its location, at the entrance to the Senate wing is admirable in every way, the effect upon one ascending the steps for the purpose of entering the building is most impressive. This pair of doors was the last work executed by Crawford. He put a great deal of labor on it, and regarded it as his masterpiece, but unfortunately did not live to see it completed in bronze. The pair of doors designed by Rogers at the main entrance is even more advantageously located. In general design the two compositions are in accord, but Rogers in his has represented scenes in the life of Columbus, and has introduced a number of portraits of the great navigator and his contemporaries.

The invitation to compete for the execution of the sculptures of the Capitol which Powers professed to regard as an insult, was willingly and unhesitatingly accepted by Crawford, who was inspired by an honorable ambition to have his name handed down to posterity in connection with great works of truly national importance. He found a warm advocate in Senator Sumner, who had been one of his earliest patrons, and the commission which he was successful in obtaining was the most extensive and important ever given by the government to any artist. The selection of Crawford to make the group for the north pediment, the colossal statue for the dome, and the bronze doors for the north entrance was fortunate, for it is exceedingly doubtful whether any other American artist of the day—excellent as some of them might have been—could have executed the work in such a satisfactory manner as he did—for Crawford's work undoubtedly is satisfactory, even if it fails in some particulars to realize the ideal of what such work should be.

The best of all the statues executed by this artist for the Capitol are

the huge Liberty which surmounts the dome, and the Indian Chief mourning over the decay of his race, which fills the north angle of the north pediment. This last is an exceedingly original and an exceedingly impressive figure. The Indian is seated and his bent head is resting on his right hand, while the left hand, resting on his knee, is clenched with a most expressive gesture of a despair which sees absolutely no outlook for the future. The admiration which this fine statue excited, especially among the artist's professional brethren, was most cordial, and the English sculptor Gibson, after Crawford's death, was very anxious that a replica in bronze should be made for the purpose of being placed upon his tomb. The other figures in the pediment group, representing the mechanic, the merchant, the school-master, a couple of school-boys, a settler felling a tree, and so forth—the whole being intended to typify the advance of civilization —are some of them executed with great spirit. The radical defect of these sculptures is, however, that they do not compose. The artist had a subject—although it must be confessed that it was not a particularly inspiring one—but he failed utterly to appreciate the importance and even necessity of treating it as a whole. The group, considered as a group, has no unity of design; it is nothing more than a collection of individual figures, which the spectator is at liberty, if he chooses, to imagine as having a relation to each other, but which in reality have no real and no true artistic connection. The failure of Crawford to make a genuine group in this instance is the more to be regretted, as his work for the most part is up to a high standard of excellence.

The colossal Liberty, which so admirably and appropriately finishes the imposing and graceful dome of the Capitol, is, or ought to be, familiar to all good Americans through the medium of the finely executed engraving of it on the five dollar legal tender notes of the government. This figure has been severely criticised in detail, and as a whole, but we

have always regarded it as a peculiarly successful performance. It is an attempt at the personification of an abstract idea, and it perhaps does not succeed any better in conveying such idea to the mind than do many other attempts of a similar character that have been made by better and worse artists than Crawford. It is only a very few of the greatest men who really do succeed at this sort of thing, and Crawford's Liberty, we think, ought to be judged as a portion of the architecture of which it is the crown, rather than as the embodiment of an abstraction. It certainly does express an idea in a reasonably acceptable manner in accordance with certain conventions, but its real merits are not so much in its fitness to stand as the ideal Liberty, armed and watchful, as they are in things more absolutely technical. There is a genuine dignity and a genuine nobility about the figure, and the boldness with which the artist has departed from strictly classical precedents in the management of his draperies, and especially in the treatment of the head-dress, add to rather than detract from the impressiveness of the work. If as an allegory, it is not more successful than many other sculpturesque allegories, at least as a symbolical statue which fulfils certain accepted conventions it is one of the most successful works of its particular class of modern times. This statue undoubtedly would have a far higher value did it mean more than it does, for the popular imagination does not readily find itself in accord with conventional artistic symbolism—and in that the popular imagination is not so much at fault as many artists and their apologists represent it as being. The first essential, however, of a work of sculpture, designed as this one was, to crown a lofty and imposing pile of architecture, is that it shall obviously be intended to mean something, and something in keeping with its accessories; and the second is that its pose, its masses and its outlines shall refresh and satisfy the eye. One of the finest, if not the very finest, works of the class to which Crawford's Liberty belongs, which has been designed in our time, is Bartholdi's Liberty

Lighting the World, which it is proposed to erect on Bedloe's Island in New York harbor. In this the French sculptor has succeeded better than the American one did in expressing an idea, but even admitting the superiority in significance and in classic grace and classic severity of treatment in Bartholdi's figure, are there not a richness and a variety in the outlines of Crawford's statue as it defines itself against the sky, that we would not be willing to lose, even for a more purely classic grace and severity? One of the most striking and most admirable features of Crawford's Liberty is the eagle-shaped helmet with its circlet of stars. This helmet was the subject of much controversy at the time the design was under consideration, and it has been the subject of much and very various comment since the completion of the work. In Crawford's original design the figure was crowned with the Phrygian bonnet, which, from being among the Romans the symbol of a freedman, has among the moderns come to be regarded as a symbol of that freedom which has never acknowledged bondage. This liberty cap was objected to by Jefferson Davis, who was Secretary of War at the time, and who was one of the Commissioners having supervision of the works of art being executed for the Capitol, on the ground that it was not an appropriate adornment for a statue which was supposed to represent the guardian genius of a people which had always been free. The artist, for his part contended that, whatever signification the Phrygian bonnet might originally have had, it had come to be regarded as the symbol of free-born liberty, and, that, as his work was intended for the people, it should speak to them in a language which they would understand without an interpreter. Both the artist and his critic were right, from their several standpoints, but, we think that Crawford must have been impressed by the arguments of the Secretary, and must have believed that his figure would be improved by the adoption of some other style of head-dress, or he would not so readily have consented to make the alterations he did, especially as Davis does not seem to have been at

all obstinate in insisting upon having his ideas carried out. We have never seen Crawford's original design, but we have very little difficulty in believing that the effectiveness of the statue has been considerably increased by the substitution of the eagle helmet, with its boldly sculptured coronet of stars, for the liberty cap. Because Jefferson Davis subsequently chose to pursue a political course that brought upon him the displeasure of a considerable portion of his countrymen, it does not at all follow that he was not capable of making a valuable artistic suggestion. We say this because the objections to the peculiar head-dress of Crawford's Liberty seem to be chiefly based on the theory that it is all wrong because Davis suggested it, or at least suggested that the artist should make some alterations in his original design.

The only other important public work undertaken by this artist— unless we account his very admirable statue of Beethoven in the Boston music hall, as a public work—was the Washington monument at Richmond. He made the design for this and completed the equestrian statue of Washington—the casting of which was made the occasion of a complimentary fete to the artist by the artists and art-lovers of Munich—but did not live to finish all of the accessory statues and the decorations. After Crawford's death, Randolph Rogers, a sculptor of sympathetic genius, who had been on terms of close and fraternal intimacy with him, was invited to finish it. After Rogers accepted this peculiarly delicate commission, it was decided to make some alterations, or rather enlargement, in the design, with a particular view of doing honor to the memories of a greater number of distinguished Virginians, by the introduction of their statues as accessories. It is admitted, on all sides, that the alterations were made with judgment, and that they increased the richness of the composition. The monument as it stands, is, therefore, the work of both sculptors, and

Rogers fairly earned the right to have his name inscribed beside that of Crawford upon it.

The numerous works executed by Crawford for the government illustrated but a single phase of his prolific and versatile genius. He excelled in every branch of sculpture, and, as neither his invention nor his industry ever seemed to flag, the enumeration of his designs would make a very lengthy list. After his death his widow presented to the Commissioners of Central Park, New York, eighty-seven plaster casts from his studio. Included in these, were, of course, a number of designs which had been executed in marble or bronze, but many of them were sketches and studies in various stages of advancement, from the first crude definitions of ideas to models nearly completed and ready for the marble cutters or foundrymen to take in hand. Among the most notable of his completed works are the bronze Beethoven in the Boston Music Hall—of which a passing mention has already been made; an Orpheus in the Boston Athenæum; a statue of James Otis in the Chapel of Mount Auburn Cemetery; an Adam and Eve after the expulsion from Paradise, a Shepherdess, and a bust of Josiah Quincy, also in the Boston Athenæum; Children in the Woods, which belongs to the Hon. Hamilton Fish; a Boy Playing Marbles; a Pandora; "Dancing Jenny," modelled from his little daughter; a Cupid; a Genius of Mirth; a Flora—in the New York Central Park; a Hebe and Ganymede; a Mercury and Psyche; the Daughter of Herodias; an Aurora; and a Peri. A copy in bronze of his Indian in the north pediment of the Capitol is in possession of the New York Historical Society. In addition to these statues he sculptured more than twenty bas-reliefs of scriptural, classical, and other subjects.

The Orpheus in the Boston Athenæum was Crawford's first ideal work, and by many excellent judges it is thought that in subtle suggestiveness

it is not surpassed by any of his later efforts. It was this statue that won for the artist the warm regards of the Hon. Charles Sumner. That gentleman not only admired it greatly, but he made his admiration of practical value by inducing a number of wealthy Bostonians to subscribe for its purchase. The Orpheus—Orpheus descending into hell in search of his lost love Eurydice—was sculptured in Rome just after the artist was fairly out of his tutelage. It was in Rome that Crawford received all of his artistic education, except what bits of knowledge with regard to the manipulation of material he was able to pick up in a marble-yard where he worked for some time before crossing the Atlantic. In Rome he studied in the Academy, and he had the benefit of Thorwaldsen's advice and instruction, as Greenough and many others had had before him. Thorwaldsen, in fact, took a very lively interest in all young artists of promise, and possibly in a good many that did not promise anything, for he had the reputation of being too good-natured to discourage anybody who came to him for counsel, and consequently of having induced more than one young man with not a spark of genius or even talent, to attempt things that nature never intended that they should attempt. In Crawford's case, there is no doubt that the assistance of the Danish sculptor was of the greatest value, for Thorwaldsen was no common man, and with his ideas regarding the poetical aim which true art ought to have, he was capable of doing much towards starting an ardent and inventive youth like Crawford on the right path. Crawford was a native of New York and was born in March, 1813. He died in London, October 16, 1857, at a time when his genius was in its full maturity. He did not die of over-work, or of an overstraining of his powers, but of a peculiarly painful tumor in one of his eyes, which had for a considerable time before his death incapacitated him from any practice of his profession.

Randolph Rogers was also born in New York, but twelve years later

than Crawford. He devoted himself seriously to sculpture at a later period than did Crawford, and is one of a considerable number of American painters and sculptors who have drifted into art from other pursuits. It is difficult even now for an artist to thoroughly qualify himself for the practice of his profession without going abroad to at least complete his education, notwithstanding that we have a number of art schools and academies in operation; thirty or forty years ago it was an impossibility. Considering the disadvantages under which they have labored it is really wonderful that American artists, and especially American sculptors, have succeeded in doing such very excellent work as they must be credited with. A sculptor, even more than a painter, needs exactly the kind of training that can only be obtained in a school where the human form is made the basis of study. Dealing with the human form almost exclusively, it is essential that he should study it from a constant succession of living examples. The antiques, it is true, will teach him much, but there is a great deal that they cannot teach him. Even, however, were it possible for a student to learn all that need be learned from the antiques, the fact that a close and exclusive study of them invariably has the effect of stifling real invention and real originality, and of inducing the artist to become a mere copyist of men long dead and gone, is of itself sufficient to compel a sculptor who wishes to preserve his own individuality, to go to the fountain-head from which the great master artists of the classic period drew their inspiration.

Rogers when he decided to be a sculptor went to Rome, for it was there that the best opportunities were offered, both for the study of nature and of the noblest remains of antique art. He studied hard for several years, and he then came before the public with two statues which at once gained him celebrity, and placed him in the front rank of the sculptors of the day. These statues were a Boy and a Dog and Nydia the Blind

Girl of Pompeii. The last named, especially, was greatly admired, and it is even at this day one of the most popular statues that has ever been executed by an American artist. Numerous copies of it, which have been made by the artist at the demand of eager purchasers, are in European and American collections, and, at the Centennial Exhibition of 1876, it and a Ruth —which was sculptured at a later period—figured prominently among the works in the American section. Rogers has executed so many, so important, and such meritorious works that it is impossible to regard the Nydia as marking the culmination of his artistic career, in the same way that we are forced to regard the Greek Slave as marking the culmination of that of Powers. The later performances of Rogers, however, while they may show an increase of technical skill, do not excel this spirited and thoughtful statue in any of the essentials of true artistic excellence. The Ruth, for instance, which stood beside it at the Centennial Exhibition, and which represented a larger experience and a wider range of skill, did not attract a tythe of the attention that the Nydia did, and did not awaken a tythe of the admiration. And yet, in the one the artist had quite as fine a subject as in the other, although he failed to obtain the same amount of inspiration from it. The heroine of the lovely Hebrew idyl is represented as resting one knee on the ground as she gathers the gleanings in the field of Boaz. In her lap are her gatherings, while her right hand is filled with such of the ripened grain as she has just collected from the ground. The head is turned as if she had glanced up a moment from her task to gaze at the figure of Boaz in the distance, and there is a peculiar expression imparted by her eager eyes and her half-opened mouth, as if she was hesitating between hope and fear with regard to the result of her scheme for securing the protection of her rich kinsman. All the essentials are there when we come to closely examine the figure, and yet the artist has somehow failed to adequately express all that was evidently in his mind, and it requires a considerable stretch

of the imagination to believe in his Ruth as Ruth, or as anything else than a pretty young woman posing in an interesting attitude.

The Nydia, on the other hand, is full of expression, and it tells the story of the search of the blind girl of Pompeii for her lover in the midst of the awful scenes that marked the last hours of the doomed city, as clearly and intelligibly as it would be possible to tell it with the limited resources of the sculptor's art. But, the Nydia does something more than tell a story clearly and intelligibly—for a work of art might readily do that and yet fail altogether in things that every true connoisseur and every true art lover must regard as matters even more essential. Let us, before discussing the statue further, quote Bulwer's description of the scene of devastation amidst which the blind girl is wandering and listening, with the hearing sense exquisitely attuned, for the voice of her beloved to come to her through the thunders of the volcanic tempest, and through the showers of ashes and scoriæ that are falling around her:—

"Another—and another—and another shower of ashes, far more profuse than before, scattered fresh desolation along the streets. Darkness once more wrapped them as a veil; and Glaucus, his bold heart at last quelled and despairing, sank beneath the cover of an arch, and, clasping Ione to his heart—a bride on that couch of ruin—resigned himself to die.

"Meanwhile, Nydia, when separated by the throng from Glaucus and Ione, had in vain endeavored to regain them. In vain she raised that plaintive cry so peculiar to the blind; it was lost amidst a thousand shrieks of more selfish terror. Again and again she returned to the spot where they had been divided—to find her companions gone, to seize every fugitive—to inquire of Glaucus—to be dashed aside in the impatience of distraction. Who in that hour spared one thought to his neighbor? Per-

haps in scenes of universal horror, nothing is more horrid than the unnatural selfishness they engender. At length it occurred to Nydia, that as it had been resolved to seek the sea-shore for escape, her most probable chance of rejoining her companions would be to persevere in that direction. Guiding her steps, then, by the staff which she always carried, she continued, with incredible dexterity, to avoid the masses of ruin that encumbered the path—to thread the streets—and unerringly (so blessed now was that accustomed darkness, so afflicting in ordinary life!) to take the nearest direction to the sea-side.

"Poor girl! her courage was beautiful to behold!—and fate seemed to favor one so helpless! The boiling torrents touched her not, save by the general rain which accompanied them; the huge fragments of scoriæ shivered the pavement before and beside her, but spared that frail form; and when the lesser ashes fell over her, she shook them away with a slight tremor, and dauntlessly resumed her course.

"Weak, exposed, yet fearless, supported but by one wish, she was the very emblem of Psyche in her wanderings; of Hope, walking through the Valley of the Shadow; of the Soul itself—lone but undaunted, amidst the dangers and snares of life!"

There is, perhaps, not more in such a scene as this that is essentially dramatic than there is in the Hebrew idylist's description of Ruth gathering the handfuls which the reapers of Boaz let fall for her, but there is more that requires the execution of an artistic *tour de force* for its representation or suggestion in a work of sculpture. In attempting to represent Nydia seeking for Glaucus amidst the showers of ashes belched forth by Vesuvius, the artist finds the line between brilliant success and absolute failure more closely drawn than he does when he essays to represent Ruth

gleaning in the field of Boaz, and the reason for the qualities in Rogers'
Nydia which have secured for it its fame, and for its superiority over his
Ruth, and indeed, over any of his ideal creations are not difficult of
comprehension.

The skillfully executed etching by Mr. Stephen J. Ferris which is
before the reader, renders any elaborate description of Rogers' Nydia
unnecessary, but it is worth while to invite attention to some particular
points of excellence in it. The crouching attitude, and the tempest blown
garments which entangle themselves in the blind girl's staff are thoroughly
expressive of a hurried forward movement—or rather of a slight pause in
such a movement for the purpose of listening for some hoped for voice
to pierce the darkness and the tumult. The girl's face has an expression
of intense listening upon it, and the artist has increased the suggestiveness
of both face and figure in this respect by the action which he has given
to the left hand and arm—the arm crossing the body and the back of
the hand making a shield behind the ear to gather in the sound. This
movement of the hand and arm is so obvious, that on looking at the
statue, it is difficult to think that the artist could have chosen any other
to express his idea; and yet, it is in just such niceties as this that the
superior excellence of many of the finest works of art consist. It was
an analogous movement that Michael Angelo imitated in his Adam on
the Sistine Chapel ceiling from one of the figures on the last pair of
gates made by Ghiberti for the baptistery at Florence, and it was the
profusion with which just such simple, natural and obvious movements
were suggested on those gates that made them exert the positive influence
they did in carrying the renaissance movement to a point where it was
able to stand alone, and to produce works that were worthy to be ranked
with those of the older civilization. It apparently ought not to be difficult
for art to find an abundant inspiration in the infinite suggestiveness of

nature, but it apparently is exceedingly difficult, or else there would not be so few works of art which delight us, mainly because they fix in marble or bronze, or on the painter's canvas, a limited number of the multitude of expressive gestures in which nature, in her prodigal variety, is accustomed to deal. In the suggestion of Nydia's blindness, the sculptor had a problem of the most difficult kind to solve, but, how well has he solved it, not only in the pose of his marble figure, but in the peculiar expression of the eyes and face! The very adequate manner in which the blindness of the girl is suggested, is indeed one of the most admirable characteristics of this interesting statue.

The bronze doors for the National Capitol, to which reference has been made, were finished by Rogers in 1858. His contributions to the Washington monument at Richmond, which was not completed by Crawford, were some ornaments called for by the enlargement of the design, and statues of Chief Justice Marshall and his father Colonel Thomas Marshall, of George Mason, the author of the Declaration of Rights and the Constitution of Virginia, and of Thomas Nelson, one of the Signers of the Declaration of Independence, and the successor of Jefferson as Governor of Virginia. In addition to these, Rogers has sculptured a number of important monumental statues, the one which is distinguished by the highest ideal qualities being the Angel of the Resurrection, on the grave of Colonel Colt, at Hartford, Connecticut. His colossal bronze statue of Lincoln—represented as just having affixed his signature to the Emancipation Proclamation—which was erected in 1871 in Fairmount Park, Philadelphia, is a work of very sterling qualities, and is entitled to the credit of being one of the few really successful portraits of a great man whose rather ungainly figure made him the despair of artists. Subsequently Rogers sculptured a memorial statue of Secretary Seward, which is very similar in motive to the Lincoln. The largest, if not the

most important works executed by this artist are the colossal America, fifty feet high, erected at Providence, Rhode Island, in 1875; and the yet larger statue personifying the State of Michigan, which was unveiled at Detroit in 1873. Another noteworthy monumental statue by Rogers— but of an earlier date than those mentioned—is the full-length of John Quincy Adams in the Mount Auburn Cemetery. In addition to these public works, Rogers has made many busts and ideal figures, of which, after his Nydia and his Ruth, a statue of Isaac has been the most admired.

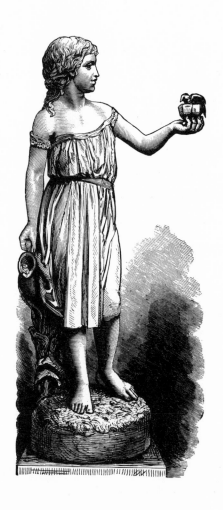

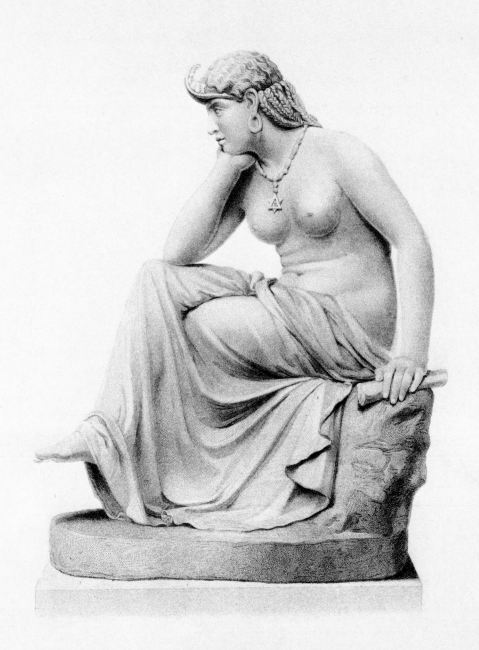

A SIBYL.

ENGRAVED BY E W STODART, FROM THE STATUE BY WILLIAM W. STORY.

CHAPTER IV.

STORY.

WILLIAM WETMORE STORY has a distinct place of his own among the American sculptors. He is not self-taught, and yet he belongs to no school, and his works are apparently uninfluenced by the style of any master. Enjoying a larger measure of fame than almost any of his contemporaries, his fame is of such a peculiar kind that the honors which it brings with it are most indefinite. While all of his principal performances have gained him great repute, the great mass of the public, both in America and in England—for he has an even greater reputation in England than he has in his own country—know little or nothing about them, except by hearsay, and the esteem in which he is held is chiefly based upon the eulogistic reports made by a limited number of ardent friends and admirers, rather than upon any actual and extended knowledge of him or his doings. Story is a fortunate man in more respects than one, but he has been particularly fortunate in enjoying the friendship of men and women who have the' ear of the public, and whose words are sure to be listened to with respect and credence. They have spoken of him, and in no uncertain terms, and the American and English publics have listened and believed, and have consented to admire without stopping to inquire whether their admiration

was in all respects worthily bestowed. Thus it has happened that Story has, almost without a word of dispute from any one competent to speak authoritatively on such a subject, come to be regarded as the greatest of living American sculptors—for he assuredly is so regarded by many of the most cultivated art-lovers on both sides of the Atlantic.

Story, however, does not owe the peculiar kind of reputation which he enjoys entirely to his acquaintanceship with eminent literary people who have found it a pleasant thing to write about him, and to sound abroad his praises. It is, perhaps, not too much to say that he is the most all-accomplished artist of the present day—no American sculptor or painter, at least, can rival him in the extent and variety of his accomplishments. With the American public he is undoubtedly better known and more highly esteemed as an author than he is as a sculptor—that is, the American public understands and appreciates his worth as an author, and is content to take his statues on trust, in the faith that so learned and so charming a writer could not be a bad sculptor. Like Dante Gabriel Rossetti, the one-time leader of the English pre-Raphaelites, whose paintings are so rarely exhibited where they can be examined and criticised, his literary has aided and upheld his artistic reputation. Unlike Rossetti, however, he has never put himself forward as an artistic theorist, and has never attempted to make himself the founder of a school. It is, perhaps, fortunate that Story never has attempted anything of the kind, especially in view of Rossetti's palpable failure, although when we consider the undoubted influence which his theories have exerted in advancing the standard of contemporary English art, the originator of the pre-Raphaelite movement really has nothing to reproach himself with in the fact that that movement did not result in accordance with his wishes. As a sculptor, Story has much in common with the English pre-Raphaelites, who, with Rossetti at their head, and with Ruskin to passionately plead

their cause, and to extravagantly extol their eccentricities, created such an upturning of old-fashioned artistic ideas in England and America nearly forty years ago. He has always aimed at placing that ideal something, which the really cultured men among the pre-Raphaelites claimed was the soul of art, above the mere substance, and in all of his ideal statues there has been at least the attempt to express distinct although subtle ideas, while his portraits, whether full-lengths or busts, have sought to combine the severest literalness with a searching analysis of that inner man, to which the fleshly covering is but a mask.

It is not unlikely that Story would be among the first to disclaim any artistic kinship with the pre-Raphaelites, but, apart from the eccentricities and affectations of mediævalism which distinguished the performances of the lesser men of the school, rather than those of its leaders, his principles are essentially theirs. If he has not exerted the same influence for good or ill that they have, the reason, perhaps, is that he has made absolutely no effort in that direction, and, particularly, that he has been persistent in the attempt to win distinct celebrities, both in art and literature. Had he chosen to make his talents as an author subservient to his art, there can be no doubt that he would have exerted a most potent influence, but then the world might have lost some books that the world now would be loth to lose. The only writings by Story on purely artistic subjects that we know of, are the papers entitled, Talks in a Studio, which were published several years ago in Blackwood's Magazine, but which have never been collected in book form. These, it is true, did not deal exclusively with artistic topics, but, representing as they did the friendly chatting of an artist and a cultivated man of the world of sympathetic tastes, "in a studio," while covering the whole ground of literature and art, they naturally dwelt with particular emphasis on such subjects as the supposed surroundings of the interlocutors would be apt to suggest.

These dialogues, although they have never been published in such a shape as to be accessible to every reader, well deserve to be, for they not only give an insight into Story's way of thinking about art and its objects and aims, and reveal many of the secrets of his own methods, but they contain many acute and exceedingly valuable criticisms. The analyses of the styles of Michael Angelo and Raphael, and the comparisons between them, which are given in one of the conversations, are contributions to critical literature of the first importance. The great Florentine is discussed reverently, but Raphael is evidently regarded by Story as having been placed on too high a pedestal by over zealous admirers, and the estimations of the limitations of his genius are well worthy of the perusal and of the candid consideration even of those who may be compelled to differ most widely with the writer in the conclusions he arrives at.

Story's best known and most deservedly popular book is his Roba di Roma. This is much more than a mere description of modern Rome, for the author has gone deep down into the heart of his subject, and has dug out from the moral as well as the physical crust which hides the real Rome from the eye of the casual visitor an infinite variety of rare and curious facts which he discusses in learned, eloquent and eminently picturesque language. This is such a book as only a foreigner could have written about Rome, and only a foreigner who had resided in the city for a long term of years, and had examined every nook and corner with the keen and critical eye of a trained author and artist. But, Story was an author before he was a sculptor, and before he saw Rome. In addition to his biography of his father, Chief Justice Story, he wrote a legal treatise on the Law of Contracts—for he originally adopted his distinguished father's profession—and a volume of poems. He has always been ambitious of obtaining celebrity as a poet, and it is said that he thinks more of his poetical performances, and more of such fame as they have brought him

than he does of his sculptures and his reputation as a sculptor. The appreciation of his poetical efforts, however, is confined to a comparatively limited circle of admirers, and with the general public his repute as a writer rests upon his prose works. As has happened to more than one man who has essayed to obtain distinction in different lines of art, his fame as a poet has been overshadowed by that which he has won as a prosateur and as a sculptor. Some of his poetical writings, however, deserve to be much better known than they are. One of his most elaborate and most characteristic poems has for its theme the Remorse of Judas. This singular piece is in a certain sense a defense of Judas, the idea being that the treacherous Apostle was anxious to solve the doubts which, in spite of his efforts to stifle them, would arise in his mind as to the verity of the Messiahship of his Master, by a test which would at once satisfy himself and all the world; and, that overcome with remorse at the immediate consequences of his treachery, he went out and hanged himself, without waiting to see the ultimate results of his experiment. This poem, like the Talks in a Studio, was published some years ago in Blackwood's Magazine, but, so far as we are aware, it has not been reprinted in any collected edition of the author's works.

But Story is not only a writer of prose and poetry, in addition to being a sculptor; he draws and paints—as every sculptor ought to do occasionally, for practice sake, even if he produces nothing that he deems worthy of being placed before the public—and he is an accomplished musician. Architecture appears to be the only one of the arts he has not tried his hand at, which is somewhat remarkable, for the classic sculptors, as well as those of the renaissance, were nearly all of them architects, and the relations between sculpture and architecture are more intimate than they are between any of the other arts. Indeed, it is not too much to say that a sculptor ought to be an architect, even if he

does not care to follow the example of Michael Angelo and others in designing buildings and superintending their construction. The nearly absolute divorce between sculpture and architecture in our day is a positive misfortune to both arts, and sculptors of the learning and intellectual attainments of Story could scarcely do themselves or the public a greater service than by devoting a considerable portion of their time to the study of architecture—at least to the extent of qualifying themselves to speak with authority concerning the designs, construction and ornamentation of buildings which are monumental in their character. Architecture in this day, and especially in this country, needs, and greatly needs, just the kind of keen critical interest to be taken in it which accomplished artists, and especially accomplished sculptors, are alone able to take.

As has before been stated, few of Story's sculptures have been placed on public exhibition, and, consequently, the opportunities afforded, not only to the public but to connoisseurs, for giving them critical study and for forming estimates of their artistic value, have been provokingly limited. His most celebrated works of a purely public character are the statue of Edward Everett in the Public Garden at Boston, and that of George Peabody in London. For the execution of the latter choice was made of Story as the most distinguished of living American sculptors—at least the most distinguished in the eyes of Englishmen. Story, in fact, has all along enjoyed a higher reputation in England than he has in his own country, both as a litterateur and as an artist. In the Exhibition of 1862 his statues of Cleopatra and the Libyan Sibyl were the only contributions by an American artist that elicited cordial expressions of admiration, just as the Greek Slave of Powers was the noteworthy representative of American art in the Exhibition of 1851. Either the Cleopatra or the Sibyl, however, had more in it to excite genuine admiration than had the Greek Slave, and those who best remembered Powers' work were

glad to hail these two statues as tokens of an advance in the art of sculpture among the Americans.

The bronze statue of Edward Everett is an attempt to represent Everett the orator. It has been rather severely criticised as theatrical, and the criticism is deserved, or rather, it would be deserved as a censure were the figure not so severely accurate in the reproduction of one of Everett's favorite poses and gestures. As an orator Everett was essentially artificial and theatrical, and the artist in representing the man as he appeared in what he and his admirers regarded as his best moments, has done him no more and no less than justice. That this statue is an admirable likeness of Edward Everett in face and figure is not denied by any one, and unless the orator's character has been greatly misapprehended by a majority of his countrymen, it is just such a monument as he himself would have chosen. The bronze statue of George Peabody in London is as quiet and unobtrusive as that of Edward Everett is just the contrary. This work, in fact, if it is open to any censure is chargeable with tameness. The philanthropist is represented as seated in a large chair—too large a chair, for it very unnecessarily gives an appearance of clumsiness to the whole work—and, as in the case of Everett, the artist has been successful in giving an adequate portrait of the whole man. While this work cannot be regarded as a masterpiece, it is at least quite as great a success as most memorial statues, in its particular style, that have been made in our day. Our artists seem to be able to win success with their ideal figures in sitting postures, but for some reason they rarely manage to make the sitting figures in their monumental works truly imposing. The true secret of the non-success of this particular class of works, however, appears to be that they are not placed under cover. This is the difficulty with Greenough's Washington, and it can scarcely be doubted, that were it, and Rogers' Lincoln, and Story's Peabody removed

from their present positions in the open air and made accessories to the architecture of imposing buildings, they would gain an interest and an importance which they do not now have.

Story's most famous statue is his Cleopatra. It is the most famous, not because its extraordinary merits have forced a recognition from the multitude, but, because it had the good fortune to fascinate a man of rare genius, who, in a sense, appropriated it for his own by embodying a eulogistic description of it in one of his best known and most widely read books. The Cleopatra has, so far as we are aware, never been shown to the public except at the Exhibition of 1862, and at the sale of the collection of Mr. John Taylor Johnston of New York in 1876. A British connoisseur purchased the statue at the Exhibition, and from his hands it passed to those of Mr. Johnston. The British public, which saw this statue and that of the Libyan Sibyl at the Exhibition of 1862, expected to find in them extraordinary qualities and aims, if not absolute accomplishments, which would suggest the performances of the best days of the renaissance. The Greek Slave of Powers was not an unknown statue when the Exhibition of 1851 opened, for it had been seen and admired and talked about by a great number of persons, but it was, nevertheless, something of a surprise to the general public, and the surprise had much to do with the rather extraordinary sensation which it created. The Cleopatra of Story was not a surprise, for the public mind had been prepared for it, and the public curiosity excited with regard to it, and in such a way that a vast majority of those who came into its presence came predisposed, not only to admire, but to admire extravagantly. Hawthorne has always had a larger audience in England than he has had in his own land, and his romance of The Marble Fawn, especially,—in England it goes under the title of Transformation—is esteemed as it never has been in America, where it is not regarded by

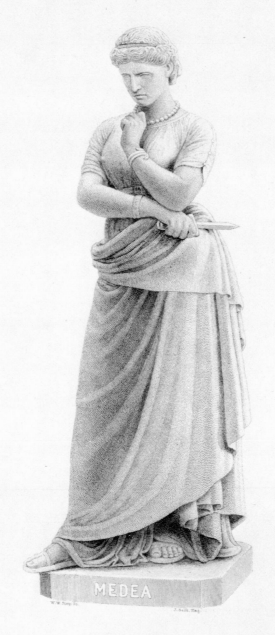

MEDEA

MEDEA.

discriminating readers as its author's masterpiece. It is in the Marble Fawn that Hawthorne gives the description of the Cleopatra which made it famous before it left the studio of the artist, and which has caused it to figure in the popular imagination as Story's most important and most characteristic work. Hawthorne looked at this statue, as he saw it in the clay, growing day by day nearer to perfection under the fingers of the sculptor, with the eyes of a romancist and an enthusiast who knew next to nothing of the technicalities of plastic art, and who was interested only in the ideal which an effort was being made to give palpable form and substance to. He was on very intimate terms with Story during his visit to Rome, and, as the published extracts from his Note-Book show, was a frequent visitor to his studio, and was, from his first sight of it, strangely interested in this particular work. The Cleopatra when Hawthorne first saw it was in a peculiarly interesting stage. It was just sufficiently far advanced for the intentions of the artist to be distinctly made out, and for something like an accurate idea to be formed as to what the full expression of the face and the pose would be. There was, however, just enough mystery about the rough clay, which had only partly been wrought into shape, to set the imagination to work, and to excite speculations as to what the ultimate result would be, and as to whether the artist would succeed in making the statue all that it promised. Before Hawthorne left Rome, the Cleopatra was finished in the clay, or very nearly so, and in view of the fascination which watching the progress of the work had for him, it was the most natural thing in the world that he should desire to include a description of it in his Roman romance. As the fame of this statue is so largely due to the description in The Marble Fawn, and as it has never been photographed nor engraved, we cannot do better than to quote the passage which refers to it. Hawthorne in his preface makes a proper acknowledgement to Story, but in the narrative itself he assigns the Cleopatra to his imaginary sculptor, Kenyon. The visitor to Kenyon's

studio, for whose benefit the nearly completed clay model is unveiled, just before the artist draws away the wet cloths in which it is swathed, expresses a dread lest it should be a nude figure, which rather amusingly reflects Hawthorne's own emotions in encountering the innumerable undraped representatives of the human form in the great galleries of Europe. The sculptor explains that the proprieties have all been observed, and also states what the subject is, in order that no unpleasant mistakes may be made, and then comes the description of the Cleopatra as the eyes of the finest and most imaginative genius that American literature has produced beheld her:—

"The sitting figure of a woman was seen. She was draped from head to foot in a costume minutely and scrupulously studied from that of ancient Egypt, as revealed by the strange sculpture of that country, its coins, drawings, painted mummy-cases, and whatever other tokens have been dug out of its pyramids, graves and catacombs. Even the stiff Egyptian head-dress was adhered to, but had been softened into a rich feminine adornment, without losing a particle of its truth. Difficulties that might well have seemed insurmountable, had been courageously encountered and made flexible to purposes of grace and dignity; so that Cleopatra sat attired in a garb proper to her historic and queenly state, as a daughter of the Ptolemies, and yet such as the beautiful woman would have put on as best adapted to heighten the magnificence of her charms, and kindle a tropic fire in the cold eyes of Octavius.

"A marvellous repose—that rare merit in statuary, except it be the lumpish repose native to the block of stone—was diffused through the figure. The spectator felt that Cleopatra had sunk down out of the fever and turmoil of her life, and for one instant—as it were, between two pulse-throbs—had relinquished all activity, and was resting throughout

every vein and muscle. It was the repose of despair, indeed; for Octavius had seen her, and remained insensible to her enchantments. But still there was a great smouldering furnace deep down in the woman's heart. The repose, no doubt, was as complete as if she were never to stir hand or foot again; and yet, such was the creature's latent energy and fierceness, she might spring upon you like a tigress, and stop the very breath that you were now drawing midway in your throat.

"The face was a miraculous success. The sculptor had not shunned to give the full Nubian lips, and other characteristics of the Egyptian physiognomy. His courage and integrity had been abundantly rewarded; for Cleopatra's beauty shone out richer, warmer, more triumphantly beyond comparison, than if, shrinking timidly from the truth he had chosen the tame Grecian type. The expression was of profound, gloomy, heavily revolving thought; a glance into her past life and present emergencies, while her spirit gathered itself up for some new struggle, or was getting sternly reconciled to impending doom. In one view, there was a certain softness and tenderness—how. breathed into the statue, among so many strong and passionate elements, it is impossible to say. Catching another glimpse, you beheld her as implacable as a stone and cruel as fire.

"In a word, all Cleopatra—fierce, voluptuous, passionate, tender, wicked, terrible, and full of poisonous and rapturous enchantment—was kneaded into what, only a week or two before, had been a lump of wet clay from the Tiber. Soon, apotheosized in an indestructible material, she would be one of the images that men keep forever, finding a heat in them which does not cool down, throughout the centuries."

The most remarkable thing about this masterly piece of word-painting is that Hawthorne appears not to have been aware that Cleopatra was of

Greek lineage. The sculptor, doubtless, was aware of the fact, and decided on easily defensible artistic grounds, to give his statue the Nubian lips and Egyptian physiognomy which seem to have so impressed Hawthorne. As a matter of fact, Cleopatra had an aquiline nose and a rounded and prominent chin—a physiognomy of the Roman rather than of the Greek type.

There is much in this description by Hawthorne of the Cleopatra, which will apply to the companion statue of the Libyan Sibyl, of which we give an engraving. This weird woman of mystery, the child of the desert, it is true is not a "serpent of old Nile," but there is about her much of that pent-up fiery energy, threatening to burst forth at any moment to scorch and consume, which marks the Cleopatra. The mission of the Sibyl, however, is not to lure men on to destruction—she is the custodian of secrets, the secrets of Africa and the African race. And, how close she keeps them, with her locked lower limbs, her one hand pressing her chin as if to keep in the torrent of words that threaten to burst forth, while the other grasps a scroll covered with strange characters, which would reveal much could we be permitted to decipher it. On her head is the Ammonite horn—for she is a daughter of Jupiter Ammon, and the keeper of his oracles—and on her breast is the ancient symbol of mystery, as she sits there brooding and thinking, and her breast heaving with emotions as she thinks of what is past and what is to come. It is worth while, in looking at this figure, to recall the fact that while the sculptor was in the act of creating it Africa was giving up her ancient secrets; the world-old mystery of the Nile was being revealed, and the heart of the great continent was being penetrated in every direction by explorers who were anxious to tell the world all that it contained. The mystery of the future of the African race?—that is as great a mystery as ever.

A considerable number of Story's most important works are of the

same *genre* as the Cleopatra and the Sibyl. Both power and subtlety are imperatively demanded in statues which shall be even suggestions of such men as Saul and Moses, or such women as Judith, Sappho, Delilah and Medea, or which shall adequately symbolize Jerusalem mourning over her fallen greatness, or which shall rise above the level of mere prettiness in dealing with such a subject as Love questioning the Sphynx. These themes prove, of themselves, that the sculptor has aimed high, and if he has at times failed to realize his own ideals, his successes have been sufficiently frequent to gain for him a position altogether apart from the majority of his contemporaries.

It was during the progress of the Centennial Exhibition of 1876, in Philadelphia, that the American public was first afforded a reasonably good opportunity of forming an estimate of this artist's merits. His Medea —which is very adequately represented by our engraving—was shown in the Exhibition, while his Jerusalem was to be seen in the Pennsylvania Academy of the Fine Arts, it having been presented to that institution a short time before the opening of the Centennial Exhibition, by Mrs. N. Grigg, of Philadelphia. In the Jerusalem the idea which the sculptor had in his mind is, perhaps, clearly enough expressed, but the statue is certainly not a pleasing one. There is a stiffness and a total lack of grace in the lines of the figure for which there is no reason and no excuse. The Medea is far more satisfying, although in looking at this statue, the question involuntarily arises, why, if the sculptor violated history in giving his Cleopatra Nubian features, did he not adhere to tradition in representing the Colchian sorceress as other than a Greek? For a Greek this beautiful woman with the beetling brows and the dagger in her hand assuredly is, and she might better be called Clytemnestra, or Phædra, or the Tragic Muse, than Medea the barbarian, whom Jason discarded, and who revenged herself upon him with the blood of her

own children. Beautiful as the face of this woman with the knitted fore-head and tortured brain may be, it is not that of such a Medea as is revealed to us in the acting of those great histrionic artists, Adelaide Ristori or Fanny Janauschek—for, different as are the methods of these actresses, they have neither of them been able to conceive of a Medea who, in appearance and character, did not mark the width of the gulf between barbarian and Greek civilization, between the sorceress and the Greek horror of sorcery.

While most of Story's works have been cast in a heroic mould, he has sculptured several statues, such as an Infant Bacchus and Panther, and a Little Red Riding Hood, which address themselves without reserve to unheroic sympathies. An equestrian statue of Colonel Shaw, the hero of Fort Wayne, which was executed for the city of Boston, and a full-length of Josiah Quincy are noteworthy examples of his present statues. His busts of the poets Shelley and Keats are not so much attempts at portraiture as they are idealizations in the same sense that his Cleopatra and his Sappho are. The Shelley is a purely ideal work—that is, the sculptor did not make any attempt to follow the meagre and amateurish pencil sketch of the poet's profile, which is the only authentic portrait of him in existence; the Keats, on the other hand, is a true portrait, although an idealized one. This is chiefly based on the recently recovered death-bed study of the features of Keats, which was made by his friend, the American artist Severn, while in attendance on him during his last hours. These two busts have been warmly praised by those who have been fortunate enough to see them, and pronounced among the most masterly of Story's performances. At this writing, Story is engaged on a national monument to be erected in Independence Square, Philadelphia. It is a colossal statue of a female figure personifying Liberty, which is to be mounted upon a pedestal enriched with figures in high relief representing the States of the Union

Story was born at Salem, Massachusetts, February 12, 1819. He was a man of mature years and of some celebrity when he decided to abandon the profession of the law, to which he had been educated, for art. To the study and practice of art he brought a cultivated mind and a fervid imagination; and, being a man of wealth, as well as of liberal education and large culture, is more fortunate than many of his artistic brethren in being spared the necessity of executing crude and immature works, or of lowering his artistic standard to suit the whims and caprices of purchasers.

CHAPTER V.

ROBERTS, BAILLY, HARNISCH AND RUSH

ERHAPS the realists and the idealists, if they were to compare notes instead of abusing each other, and were to come down to exact definitions of terms, would discover that true realism and true idealism are not so wide apart as they think they are. Many who pride themselves on being realists fail altogether to understand what artistic realism is, while, on the other hand, those who shut their eyes to the truths of nature, in the hope and expectation that some inner light will guide their hands in the painting of a picture or the sculpturing of a statue, are following a false and treacherous guide that will be apt to lead them into bogs and quagmires which will overwhelm them and their hopes. Much of what passes for realism in art in their days is simply not realism at all, and represents nothing but grossly mistaken aims and radical misapprehensions as to the varied but limited possibilities of the pictorial and plastic arts. Much of that which passes for idealism is but the crude presentation of crude and half-formed ideas, and the pretence of attempting to represent something above and beyond nature, is made to serve as an apology for thoroughly unworkmanlike performances.

A painter or a sculptor cannot represent with the material at his

96

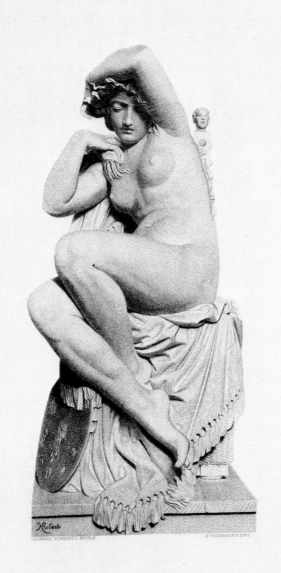

LA PREMIÉRE POSE

command all that there is in a particular object that he may choose for his model, and he consequently finds himself compelled, if he would adequately represent such facts as are within the range of his art, to make some compromises. For instance, a painter who wishes to depict on his canvas a scene or object which may strike his fancy, must place himself at such a distance from it that he can at one glance take in the whole subject. At such a distance it will be impossible for him to see every minute detail, and even many of the details which he will see will not be essential to the effect, considered as a whole. That is, he will find the objects dividing themselves into masses of light and shade and color, and if he accurately represents these masses upon his canvas he will have a reasonably satisfactory picture, even if he pays no attention to the smaller details. Obviously the principle of working by masses can be carried much too far, and, as a matter of fact, it often is carried too far; but the "impressionists," as a certain modern school of French painters, who seek to depict only the casual impressions which nature makes through hasty glances of the eye, really come much nearer to a satisfactory description of nature than do the men who endeavor to paint every vein on a leaf, for the veins on a leaf contribute little or nothing towards pictorial effect. A genuine realist is one who accurately and relentlessly copies so much of what he sees in nature as properly comes within the range of his art. An idealist is one who uses nature as a medium for the fixing of the coinings of his brain in a palpable shape, but to do this he must have the facts of nature at his finger's ends, for one ignorant of these facts is not competent to go beyond them in expressing what he is pleased to call his ideas.

The controversy between the realists and the idealists is quite a modern affair, and it is distinctly a modern notion that the poetry or the ideality of a subject will excuse bad workmanship or a lack of knowledge

and genuine culture on the part of the artist. All the master artists of
the great eras of art, so far as they have given utterance to opinions or
precepts with regard to the principles and practices of art, have insisted
upon the study, and the incessant study, of Nature as the one thing
needful, not only for the beginner but also for the educated practitioner.
Leonardo de Vinci, an idealist among the idealists, in that curious collection
of memoranda which was made up long after his death from his multitude
of note-books, and was published under the title of *Trattato della Pittura,*
insists strenuously upon the close and constant study of nature, and says
not a word about idealism, about the soul of art being of more importance
than the substance, or any one of many notions of that kind which the
art student, the artist and the art connoisseur has constantly dinned into
his ears in those days. Leonardo gives this advice to painters:—

"And you, painter, who are desirous of great practice, understand,
that if you do not rest on the good foundation of nature, you will labor
with little honor and less profit; and if you do it on a good ground, your
works will be many and good, to your great honor and advantage.

"A painter ought to study universal nature, and reason much within
himself on all he sees, making use of the most excellent parts that
compose the species of every object before him. His mind will by this
method be like a mirror, reflecting truly every object placed before it,
and become, as it were, a second nature.

"One painter ought never to imitate the manner of any other;
because in that case he cannot be called the child of nature, but the
grand-child. It is always best to have recourse to nature, which is replete
with an abundance of objects, than to the productions of other masters,
who learnt everything from her.

"Whoever flatters himself that he can retain in his memory all the effects of nature, is deceived, for our memory is not so capacious; therefore, consult nature in everything."

These precepts are worthy of being printed in large letters and hung on the walls of every art academy, and if art students could be made at the very outset to learn them by heart, and to grasp their full meaning, the world would be spared the infliction of a multitude of bad paintings and bad statuary. The example of men of the enormous learning and indefatigable research and almost unbounded genius of Leonardo de Vinci, Michael Angelo and Raphael in forcing nature to be their servant rather than their mistress, and in using with the freedom of masters the facts of nature in order to more completely express what they had in their minds, has deluded innumerable modern artists into the belief that accurate knowledge is something that one who has ideas—or who fancies that he has them—can safely dispense with. All that these great artists accomplished they accomplished by means of their knowledge, gained at the expense of great labor and study, and it is an absurdity for men of lesser attainments, no matter what their natural abilities may be, to think of rivalling them.

It is the great glory of French art of the present day that it is based on close, persistent and indefatigable study of nature. It is this, more than any superior natural aptitude, that has given the French painters and sculptors, and art workers generally, the pre-eminence they enjoy. Their theory simply is, that if a man has training, and the abundant knowledge that training brings with it, he will be able to give expression to his ideas, if he has any, and that, if a man has not training he will not be able to express his ideas in any but a crude and imperfect manner, no matter how quick his brain may be in conceiving them. In the

Centennial Exhibition, the display of French sculptures was not by any means what it might or should have been, as a number of the strongest men were unrepresented. In no other department, however, were there so many works as in the French, which seemed to be animated by the free antique spirit, while not in any way suggesting imitation of the antique. In the United States Department there was no piece of sculpture which was marked by such high technical qualities as the *Première Pose* of Howard Roberts—a work which was almost as much a product of the schools of Paris as the admirable performances exhibited in the French Department.

It would not be doing justice to this beautiful statue to intimate that its merits are exclusively of a technical character, that the artist has not done full justice to his subject as a subject, or that it is only worthy of admiration as a piece of skillful workmanship. The subject is a young woman preparing to pose undraped, for the first time, in a painter's studio, and the sculptor has indicated his own appreciation of the fact that the situation has both a comic and a tragic side, by the grotesque comic and tragic marks which he has added as decorations to the uprights of the back of the chair. As for the figure of the shrinking girl, it is full of pathos and full of infinite grace, despite the constrained attitude which she assumes as she crouches in her chair and shrinks from observation. This figure, however, is such an absolute triumph over a great number of technical difficulties that it is particularly well worthy of consideration for its technical qualities alone. Its striking and peculiar merits could only have been achieved by a man who understood the human figure thoroughly, and who had gained his knowledge of it, not from the works of other men, but from a close and laborious study of nature. They assuredly could not have been achieved by one who depended chiefly on some real or fancied inner light rather than upon absolute knowledge. From what-

ever point of view this statue is observed, it is graceful, and to secure a harmony of lines along with such a complex attitude, was in itself an achievement of the first artistic importance. But, the lifting of an arm over the head so as to partly shield the face, the bending of the other arm for the purpose of grasping at the loose drapery with which the chair is covered, the peculiar twist of the body, and the pressure of the legs against the lower part of the chair, all give emphasis to the muscular and other markings of the figure in such a way that the artist, in working out his problem, must have found the gulf between absolute success and total failure a very wide one. As will be seen by a reference to the engraving, the artist has marked with much emphasis as well as much delicacy the great variety of muscular movements with which he has to deal. The engraving, indeed, can give but a faint idea of the beauty of some portions of the work, as, for instance, the delicate markings of the flexions of the knees, or of the junction of the right arm with the shoulder. The workmanship, however, is so fine throughout that it would be an almost endless task to attempt a detailed analysis of it, and as the engraving will speak for the statue better than any written description can, we will pass to a mention of other works of the artist.

Howard Roberts was born in Philadelphia in 1843. He studied in the Pennsylvania Academy of the Fine Arts, and was for some little time under the instruction of J. A. Bailly. In 1866 he went to Paris for the purpose of completing his artistic education, and remained there for several years as a student in the Ecole des Beaux-Arts, and in the ateliers of MM. Gumery and Dumont. Both of these eminent French sculptors took a very lively interest in him, and to their instructions he doubtless owes much.

On his return to America he modelled several ideal busts, and these

being successful he attempted a full length figure. This was a statuette, about three feet in height, of Hester Prynne, the heroine of Hawthorne's romance of The Scarlet Letter. This represented Hester, with her babe in her arms and the scarlet letter, which the stern puritanism of her age decreed that she should carry about with her as a punishment for her offence, upon her bosom, standing on the pillory. The extraordinary merits of this work, which interpreted all the pathos of the subject, were acknowledged without reserve by all who saw it, and the reputation of the sculptor was at once established. After the completion of the Hester Prynne, Roberts made a number of portrait and ideal busts, the most important of these being one in which the arms were introduced, representing Owen Meredith's Lucile, and also employed himself on a full length life-size statue of Hypatia. When the clay model of this had been completed and cast in plaster, he decided to return to Europe. It was in 1873 that he once more took up his residence in Paris, and it was while there that he completed the *Première Pose*. Roberts this time remained abroad about a year, and on his return to Philadelphia he established himself in a beautiful and commodious studio, where he devoted himself to bust-making, to the modelling of a statuette—about the size of the Hester Prynne—of Lot's Wife, and to putting his Hypatia in marble.

The merely technical merits of the Hypatia are as great as those of the *Première Pose*, but the subject is such a striking one, and it is treated in such a powerful and effective manner that the statue demands to be judged on other and higher than technical grounds. This work was, after being completed in marble, put on public exhibition for a short time, and was visited by many thousands of persons. There was but one verdict with regard to it, and that was that it was the most impressive piece of sculpture that had been shown in Philadelphia for many years. This admirable statue increased the fame of Roberts even more than the

Première Pose did, for it appealed to a wider range of tastes, and a different order of sympathies. In it the beautiful Alexandrian Greek—the last of the pagans—is shown as turning at bay on the altar of the church into which she has been driven by the fanatical monks who are thirsting for her blood. The motion of turning is very finely expressed—to mention one striking point of technical excellence—and the hunted woman faces her savage pursuers with mingled indignation, disgust and despair on her face, as with one hand she clasps her tattered draperies to her breast and with the other half supports herself by means of one of the candlesticks of the altar. Fine as this powerful performance is throughout, the face is particularly worthy of admiration. It is a purely Greek face in type, and yet there is no Greek statue we know of that is marked by a strong individuality—by what we moderns call character—to the extent that this one is.

The statuette of Lot's Wife is a very singular creation, which could only have been imagined by the artist in a grotesque mood. It cannot be called beautiful, but it is most original in conception and execution, and, in spite of its grotesqueness, it is full of power and impressiveness. The woman is represented in a writhing attitude, and she is not only being enveloped in the crystals of salt which are forming around her, but she is actually dissolving into salt herself. The idea of transformation is very much more perfectly expressed in this statuette than it is in Bernini's Daphne, or in any attempts to represent metamorphosis that we know of. Lot's wife is really turning into a pillar of salt, and, admitting that the idea of such a transformation is a rather queer one for a sculptor to choose, we must also admit that it is expressed with remarkable skill.

Roberts' busts are charming, those representing childhood and womanhood especially. His ideal busts are the inspirations of a most

rare fancy, while his portraits have that inestimable quality in all portraits of showing their subjects at their best, while losing nothing of resemblance. Much of the charm of his busts is due to his refined taste and rich invention in the treatment of the hair and draperies, and about each new one that he models there is something fresh, original and fascinating; even more, however, is due to a feeling for color which is rare with sculptors, and which induces him to manage his work in such a manner as to at least suggest color by giving full value not only to masses but to individual points of shadow. Had he become a painter instead of a sculptor, he certainly would have gained repute as a colorist, for there are very few artists who are more sensitive to the subtle charms of color, and this sensitiveness shows itself in all his performances.

Joseph A. Bailly, who has been practicing the art of sculpture in Philadelphia for a number of years, is a Frenchman by birth. He was originally a wood-carver, and in view of the revival of public interest in the long-time neglected art of wood-carving, it is a matter for some regret that so talented and able a workman should have abandoned it, even for an art that is supposed to demand a wider range of powers. His work as a carver was of a high order of merit, and when he decided to devote himself to sculpture he brought to the practice of that art a very thorough training of a peculiarly effective kind. Bailly is a very rapid and very indefatigable worker, and he has turned out of his studio an enormous number of busts and statues, in bronze and marble, which deal with all manner of subjects capable of sculpturesque treatment, and many of which are works of much importance. The half life-size statue of Spring which is represented by the engraving on our title page, was one of his contributions to the Centennial Exhibition, and is a very favorable example of his graceful and fanciful treatment of ideal themes. This pretty little statue of Spring trailing her flower-bedecked robe on the earth, with its

tender and flowing lines, is as opposite in style and subject as can be to such masculine works as the equestrian statue of President Guzman Blanco of Venezuela, which stood in the rotunda of Memorial Hall during the progress of the Centennial Exhibition, the colossal statue of Witherspoon in Fairmount Park, or the dignified Washington in front of Independence Hall. The equestrian statue of President Blanco was only a portion of an important order which Bailly received from the Venezuelan government. In addition to this he made a colossal statue of the same statesman, and it is worth mentioning as an evidence of his rapidity, that although the time given him for the completion of these two difficult works was very short—so short that few sculptors would have cared to execute the commission—both statues were finished and in their places in the city of Caracas a number of weeks before the date called for in the contract. These statues gave great satisfaction to the Venezuelan authorities and citizens, and the sculptor was warmly congratulated for having contributed such imposing ornaments to the public places of their capital city. Bailly's most important ideal works in marble are companion groups entitled The First Prayer, and Paradise Lost, which represent our first parents in their days of innocence and after the fall. These are in the collection of Mr. Henry C. Gibson, of Philadelphia. Among the noteworthy portrait busts modelled by him, are those of General Grant and General Meade; he has also made models for equestrian statues of these distinguished soldiers. Since the Pennsylvania Academy of the Fine Arts has resumed its operations in the magnificent new building at Broad and Cherry Streets, Philadelphia, Bailly has filled the position of its Professor of Sculpture.

Albert E. Harnisch, a young Philadelphian of German parentage, like Howard Roberts, received instructions from Bailly, and like him was one of a small but enthusiastic band of students, which day after day and night after night gathered in the rather cramped and dismal quarters assigned

to the modelling class in the old Academy of the Fine Arts on Chestnut Street. Harnisch from the very first showed extraordinary talent. When a mere boy he modelled, and afterwards himself cut in marble a statue of Cupid, which won the heartiest commendation of the most judicious judges. This figure—the original model of which is in possession of the Philadelphia Sketch Club—is especially noteworthy on account of the originality of the pose and the singular grace and sweetness of the face and figure. The modelling is crude, and, that the sculptor lacked knowledge is plain enough to the critical eye, but, after all allowances for defects are made, it must be acknowledged that the work is exceedingly beautiful, and that its execution by so young a man as Harnisch, was a very remarkable performance indeed. Soon after the completion of this Cupid, Harnisch modelled a Wandering Psyche, a Love in Idleness, companion pieces entitled The Little Protector and The Little Hunter, a Narrahmattah from Cooper's Wept of the Wish-ton-Wish, a model for a Lincoln Monument, a number of ideal and portrait busts and several bas-reliefs. These works were all of them distinguished by great fertility of invention and a peculiarly refined and graceful fancy, and the praise bestowed upon them was so cordial that the artist was persuaded by his friends to go to Europe for the purpose of perfecting himself in his art. He has now been a resident of Rome for several years, and is rapidly taking his place in the front rank of the American sculptors stationed there. The most important of the works executed by him in Rome is an elaborate composition representing a boy robbing an Eagle's nest. Photographs of this, taken from three different points of view, which have been sent to America indicate that the sculptor is in a fair way to realize all the high expectations that have been formed with regard to him. Both the venturesome boy and the angry bird are modelled with great freedom, and are full of life and vigor, and the work as a whole is marked by high qualities of excellence.

A chapter devoted to eminent Philadelphia sculptors in a work like this would obviously not be complete without a mention of William Rush, the first American sculptor, and a true artist. Were it not that Rush was without any immediate following, and that it was not until after his death that sculpture began to be practiced to any considerable extent by artists of American birth, he would be entitled to the distinction of being named as the father of the American school of sculpture. While, however, his works have not failed to awaken the admiration of those who are competent to appreciate their very genuine qualities, they have exerted little or no influence on the growth of the art of sculpture in the United States, and they stand alone as the performances of a man who was far ahead of his age in artistic sentiments and culture, and who deserves to be much more highly thought of than he is by a present public which has bestowed abundant commendation on many men of far less eminent abilities.

William Rush was a wood-carver who was born in Philadelphia in 1757, and who died in 1833. Although he worked in the humblest materials, he was none the less an artist in the truest and best sense of the word. Indeed, considering the almost total lack of artistic culture in his day, and especially the almost total ignorance of even the most intelligent and best educated Americans with regard to sculpture and its aims and objects, it is a matter for wonder that this wholly self-taught man was able to accomplish what he did. It is nearly impossible for an artist in our day to be self-taught in the sense that Rush was, for even if a youth who desires to qualify himself for being an artist cannot avail himself of the facilities of the best schools, what with books, engravings and photographs, he can scarcely avoid obtaining considerable and very adequate knowledge, not only with regard to the artistic master-pieces of the world, but with regard to the doings of his contemporaries,

and the respective merits of contemporary schools of art. In Rush's day it was very different; communication with Europe was slow and infrequent, books were very scarce, prints were a great deal scarcer, and photographs, which have done so much to disseminate artistic knowledge and to promote the growth of artistic taste, were not in existence. He was forced to feel his own way, with little or no aid from any source, and with very little sympathetic appreciation from the people by whom he was surrounded. Despite all the disadvantages under which he labored, however, he succeeded in doing a great deal of meritorious work, which, even if it is imperfect in its modellings, and does betray the sculptor's lack of knowledge with regard to some important technical points, is so thoroughly fine in many particulars, that it is entitled to most cordial, if not unqualified admiration.

Rush's sculptures are marked by many of the characteristics of the French and Italian schools of his period, and with his limited facilities for finding out what was being done by contemporary artists on the other side of the water, he must have had a remarkably quick and receptive mind, and a remarkably retentive memory, to have been able to profit by their examples. He was, however, chiefly indebted to himself and to his study of nature for becoming the truly excellent artist which he certainly was, and his works are stamped by an individuality that acknowledges an allegiance to no schools and no masters. Many of Rush's carvings were figure-heads to vessels, and they have gone the way of the old-time specimens of marine architecture to which they were attached. Several of his most important performances in the way of busts of eminent men, ideal statues and reliefs remain, however, to testify to his genius, and to entitle him to a respectful mention in connection with the progress of the fine arts in America. The Pennsylvania Academy of the Fine Arts possesses two of his busts—one of Washington and one of himself

—and it ought to possess his exceedingly beautiful fountain statue of a Nymph Carrying a Bittern. This last named work belongs to the city of Philadelphia, as does also his statue of Washington which for many years stood in Independence Hall. Tradition has it that the beautiful Miss Vanuxem, the reigning belle of the day, posed as a model for it, and if she was as beautiful as this statue would imply, the heart-flutterings which she caused to the Philadelphia beaux were abundantly justified. This statue is of wood, and for many years it stood in the Centre Square —afterwards called Penn Square. After the completion of the Fairmount Water Works, it was removed to the charming little park which was laid out in connection with them, and was placed in position on the side of the hill just above the forebay. A few years ago it was found that this statue was badly decayed, and a bronze casting of it was therefore made, which was given the place at one time occupied by a statue of a Boy and Dolphin, on the fountain in old Fairmount Park. Strange to say, the original statue, after having been carefully copied in an enduring material, was, notwithstanding the fact of its being almost ready to drop to pieces, returned to its old place on the side of the hill, without any effort for its permanent preservation being made beyond decorating it with a fresh coat of white paint. It certainly ought to have been deposited in the Academy of the Fine Arts, or some other institution, where it would have been properly cared for. This statue is not only a beautiful work, but it is the most graceful and beautiful work of its kind in America. There is no doubt about this, for no fountain statue in this country will at all compare with it in dignity, grace, beauty, and true artistic appropriateness. In it the citizens of Philadelphia have a genuine masterpiece, which they ought to prize as something beyond price, not only because of its intrinsic merits, but because of its author. The old Park at Fairmount contains two other of the noteworthy performances of William Rush. These are the reliefs above the doors of the wheel-house. They

are compositions of superior excellence, in every way worthy of the artist, and well worthy of having an effort made for their preservation, such as was made in the case of the lovely fountain statue.

Rush was an enthusiast, but an intelligent enthusiast, in behalf of his art and in behalf of artistic culture generally. He was exceedingly anxious to have an Art Academy started in Philadelphia, and exerted himself strenuously to get one established. His efforts for a long time amounted to nothing, unless it was in calling attention to the subject, and in preparing the minds of cultivated people to appreciate the necessities of the situation, and thus smoothing the way for the enterprising and public-spirited men who finally joined with him in founding the Pennsylvania Academy of the Fine Arts.

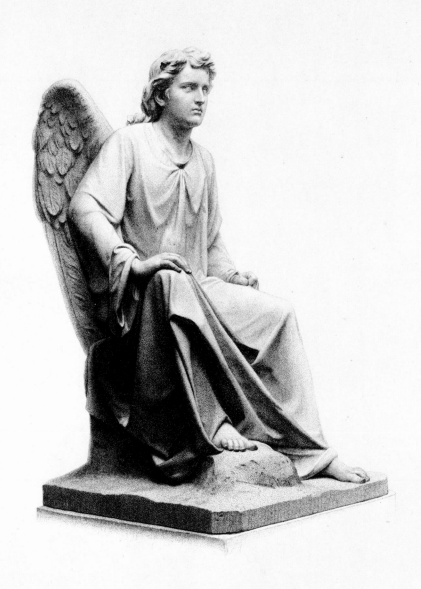

THE ANGEL OF THE SEPULCHRE.

CHAPTER VI.

BROWN, WARD, PALMER, CONNELLY AND MOZIER

NEARLY all of the sculptors whose performances have thus far been noticed were educated abroad, and represented to a greater or less extent in their works the ideas and traditions of the European schools. In this cosmopolitan age, and, in this country, which is a direct inheritor of the civilization of Europe, it is not possible, nor, perhaps, desirable, for any class of artists to ignore old world influence; but, there is so much that is peculiar and distinctive in American life, habit, customs and manner of thought, so much that calls for artistic interpretation by men who are as near as may be, distinctively American in their culture, that the careers of such sculptors as Henry Kirke Brown, John Quincy Adams Ward and Erastus D. Palmer are to be viewed with particular satisfaction. Of these three Brown is the only one who can be said to have studied abroad, and as he was a man of mature years and an artist of some repute when he made his brief visit to Europe, he is almost as much entitled to be considered as an American taught artist as Ward or Palmer. Ward had Brown for a master, while Palmer is entirely self-taught, and has made a particular effort to preserve his own individuality, and to keep himself free from the influence of all schools, ancient and modern. That Palmer has not succeeded in doing this to the extent

he imagines, must be plain to any one familiar with his works, but it is true that he has a very strongly marked individuality of style, and is almost the only American sculptor of eminence whose works are distinguished for high technical, as well as high ideal qualities who has. These three fine artists have taken up the work of old William Rush, the Philadelphia wood-carver, where he dropped it half a century ago, and as they have shown that it is possible for Americans to become sculptors, and good ones, without the aid of European instructors, it is to be hoped that they will have a numerous following, and will succeed in materially aiding to do what William Rush, in connection with Charles Wilson Peale —another man of eminent talent, whose name is worthy of being held in respectful remembrance by all true lovers of art—tried to do in the way of founding a truly and distinctively American school of art.

Henry Kirke Brown is the oldest of the trio we have named. He was born in Leyden, Massachusetts, in 1814, and originally intended to devote himself to painting. He obtained considerable proficiency with the brush, and even after he took up sculpture, he did not entirely abandon the practice of painting. That his experiences in working frequently with colors have been of the greatest value to him as a sculptor cannot be doubted. The sculptor dealing with the round without the aid of color, and the painter endeavoring to express relief by means of color, have much to learn of each other, and they both would gain by knowing more than they commonly do about each other's methods. Brown commenced the study of art in Boston, but when about twenty-three years of age he removed to Cincinnati. In that city, while doing work both as a painter and as a sculptor, he went through a rigid anatomical course under the direction of his friend Dr. Willard Parker, and it was while a resident of Cincinnati that he made his first marble bust. In a couple of years he came east again, and in 1842 he went to Italy, where he

remained for four years. While in Italy he executed several ideal statues and portrait busts. On his return to America he located himself in Brooklyn, and he has had his home, or at least his headquarters, either in that city or in New York ever since. None of Brown's performances up to the time he went to Brooklyn were very remarkable, although they were more than respectable. Shortly after going to Brooklyn, however, an opportunity was given him to distinguish himself by a commission for an equestrian statue of Washington, to be paid for by the subscriptions of wealthy and patriotic citizens of New York. This statue, which, on its completion, was erected on a peculiarly imposing site in Union Square, New York, has stood the test of the severest criticism for many, many years. Its location, in the midst of a great city, and where the currents of travel along its most important thoroughfare eddy around it constantly, is the best that could be found in the whole United States for a really admirable piece of monumental sculpture, and the most trying for an indifferent one.

The equestrian statue of General Winfield Scott, which has recently been completed by Brown for the United States government, for erection on some prominent site in Washington, is in every way up to the high standard of the New York Washington. Indeed we are not sure but that the Scott is the most admirable of the two. In it the artist has not flinched from the severest realism, and no one who has ever seen General Scott on horseback can fail to be impressed by the startlingly life-like appearance of this statue. Another of Brown's monumental statues which is thoroughly satisfying, is his General Nathaniel Greene, in the old Representatives' Hall in the National Capitol, and still another is the recumbent figure of the late Edward Shippen Burd in St. Stephen's Church, Philadelphia. The General Greene was made on a commission from the State of Rhode Island, and it is one of the very few works in the old Repre-

sentatives' Hall which rise above mediocrity, or something still lower than
this.

Ward, who was Brown's pupil, and who assisted him with his Wash-
ington, is an even stronger man. He is certainly the ablest living American
sculptor, and his best works are distinguished by a union of realistic
strength and imaginative dignity that will entitle them to the admiration
of all future generations, no matter what may be the changes of fashion
or the fluctuations of taste. Ward's father was an Ohio farmer, and from
his birth in 1830 until he was of an age when it was necessary for him
to decide as to his future profession, he lived the ordinary life of a farmer's
boy, but developing his latent artistic talents by attempting to copy in
clay and wax such engravings as took his fancy. His family, not unna-
turally, did not greatly encourage his inclinations to become an artist, and
after a good deal of persuasion he was induced to study medicine. This,
however, was so distasteful to him that he soon gave it up. His destiny
was finally decided by Brown consenting to admit him to his studio as a
pupil—a fortunate thing for the young sculptor, for it would have been
impossible for him to have found a better or more judicious master on
this side of the Atlantic. While under Brown's instruction Ward improved
rapidly, and before he was out of his apprenticeship he conceived the idea
and commenced to make designs for his Indian Hunter. When Brown
gave up his Brooklyn studio, Ward took it, and began the execution of
two important works—The Indian Hunter and a statue of Simon Kenton,
the Ohio pioneer—which brought him into immediate notice, and gave
him the position in the front rank of American artists which he has ever
since easily held.

The Indian Hunter, which is one of the principal of the purely artistic
adornments of Central Park, New York, is a wonderfully vigorous, life-

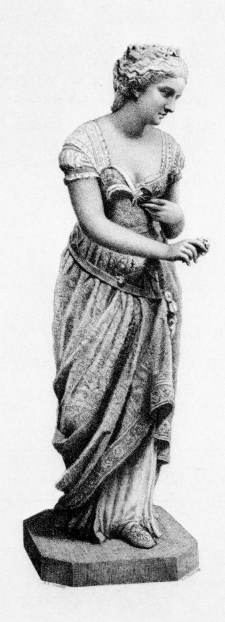

OPHELIA.

like and impressive work. It is by all odds the best and most interesting statue that the Park contains—and this not because it is American in its subject, but because of its very genuine artistic qualities. This group— for it is a group, as the dog, with the aid of which the hunter is tracking his game, plays very nearly as important a part in it as the man does —is one of the finest, if not the very finest that has been executed by an American sculptor. It is not so elaborate as Greenough's group of The Rescue at the National Capitol, but it is superior to that work in a number of important particulars, and that superiority of itself marks it as a performance of extraordinary merit. In the figure of the hunter, Ward has made a close and faithful study of the peculiar muscular development of the aboriginal races of this continent, as well as of the Indian physiognomy, for, as the reader is probably aware, not only does the Indian skeleton differ materially in certain particulars from that of the man of Caucasian descent, but the muscular development differs also. This is a nice technical point that is of considerable but not of essential importance. The great thing is that the sculptor has undertaken to represent a man engaged in a certain act which calls all of his faculties into intense and characteristic play, and that he has succeeded in doing so. Both the dog —which fairly quivers with excitement, and which is barely stayed by the cautionary hand of his master from rushing on his prey—and the Indian, who advances with stealthy step, his eye intently fixed upon the object against which he is advancing, and his whole being absorbed in the eagerness of his pursuit, are instinct with an intense vitality, which suggests not merely nature, but nature in one of his most interesting, because most unsophisticated, moods.

Another of Ward's contributions to the Central Park collection of statuary is his Shakespeare, erected at quite a recent period. There is a certain malappropriateness about the idea of making a Park statue of such

a work as this, which it is difficult to become reconciled to. The figure, nevertheless, is one of no common merit, and as an ideal representation of the great dramatist, it is exceedingly satisfying. Ward has represented Shakespeare in a meditative attitude, with one hand holding a book to his breast, and the momentary action, of a man deep in thought almost pausing in a slow saunter as an idea flits through his brain, is admirably suggested. In the head of this statue the sculptor has not given a literal translation of any one of the authentic portraits of Shakespeare that have come down to us, but he has taken suggestions from all of them, and the impression which, not the head merely, but the whole figure gives, is that Shakespeare must have been much this sort of man.

An even greater work than this is the still more recent bronze statue of heroic size of General Israel Putnam. This was executed for the State of Massachusetts, and is one of the contributions of that State to the National Sculpture Gallery in the old Representatives' Hall at Washington. The Putnam, like the Shakespeare, is an ideal work, based upon such authentic portraits as are in existence. Ward studied this work deeply, and he has made of the bluff old farmer-soldier a truly heroic figure, full of fiery energy and a dauntlessness of spirit that could not know the meaning of such a word as fear. It is such a figure as would have made Putnam's heart leap to look at, and which will always appeal, by its noble simplicity, to the manly sympathies of like-minded men with him.

Before making either the Shakespeare or the Putnam, Ward executed a considerable number of sculptures of greater or less importance. Just before the war he resided for some time in Washington, where he modelled busts of Joshua Giddings, John P. Hale, Alexander H. Stephens, and other public men. Since the war he has sculptured a memorial statue, representing a private of the Seventh New York Regiment,—a fine

work which greatly increased his already great reputation—and one of Commodore Perry. The Seventh Regiment Soldier was erected in Central Park, and the Perry at Newport, Rhode Island. Another superior performance, of a different order of interest from any that have thus far been mentioned, is the granite group of The Good Samaritan, in the Public Garden at Boston. This is a memorial of the discovery of the anæsthetic properties of ether, and in some particulars it is entitled to be regarded as the artist's greatest achievement.

Palmer, who was born April 2, 1817, in Onondaga County, New York, was brought up to the carpenter's trade, and when he abandoned it for sculpture he had the reputation of being an uncommonly good workman. While engaged at carpentering he amused his leisure by cutting cameo portraits on shells, and he was not long in acquiring a proficiency in that sort of thing, and also not very long in injuring his eyes to such an extent that he was compelled to give it up. He had discovered, however, that he had the making of a sculptor in him, and his carpenter's bench ceased to have any attractions for him. As he was very successful, in some of his first attempts at clay modelling, in developing a peculiarly delicate and fanciful vein of ideas, the public were not long in discovering his merits, and in giving him ample encouragement. Palmer improved rapidly, and he had not been working at his art many years before he was the best known and most popular of American sculptors. There was a quality in his work which pleased the average man and woman amazingly, and the photographs of his ideal statues and busts must have sold by thousands. It is creditable to him that his brilliant success did not spoil him, for, although he has persisted in ignoring all schools and all masters, he has steadily improved, and his latest works are distinguished by very positive qualities of excellence not observable in those of several years ago. His Chancellor Livingston—exhibited in the Centennial Exhibition

—is a recent performance and a very admirable one. This is a dignified and expressive statue, with a good deal of Palmer's peculiar gracefulness in the arrangement of the draperies, but with a more masculine style of treatment as a whole than was to have been expected from most of his previous efforts. This statue was ordered by the State of New York for the National Statue Gallery in the old Hall of Representatives. Most of Palmer's works, however, with the exception of his portrait busts, have been interpretations of purely ideal subjects, such as The Infant Ceres, The Sleeping Peri, The Spirit's Flight, Resignation, and Spring. The statues which have added most to his fame are The Indian Girl, The White Captive, and the Angel at the Sepulchre. Of this last we give a finely executed engraving, which very perfectly reproduces the peculiar expression of the face, which is one of the greatest charms of the statue. Is this angel sitting there guarding the sepulchre and awaiting the awaking of its slumbering tenant, or, has the dead arisen, and is he, with even his angelic intelligence puzzled by the mystery of the resurrection, listening intently at the footsteps of the approaching disciples, and considering what answer he shall give to their eager queries? A truly thoughtful work of art always suggests more than it absolutely reveals, and if, in attempting to read the expression on the face of Palmer's angel, we find that it gives forth more than one meaning, we must remember that in this respect its characteristics are identical with those of some of the greatest of the great masterpieces. While noting how thoroughly American the fine head of this angel is, we are also bound to note that both in face and figure he is of a very fleshy and unangelical type. Indeed, Palmer has always shown a singular preference for rather phlegmatic modes, and his two most important studies from the nude—The White Captive and The Indian Girl—are lacking in precisely that litheness which is one of the chief charms of the best antique representatives of the nude human figure. Both of these statues, however, have very admirable qualities.

Many of Palmer's works, particularly his early ones, have not been distinguished by refined modelling—that is, the finer markings of the form have either been neglected altogether or have not been adequately expressed. In these figures the flesh really looks fleshy, and the sculptor has evidently made a serious endeavor to express all that required expression. They are works of great beauty, and they have all the peculiar ideal charm about them that has made this sculptor's performances so enormously successful with the general public—for the general public is not, as many artists fancy, insensible to ideality in statuary and paintings, although it is insensible to a good deal that attempts to pass for as much. Such a figure as that of the Angel at the Sepulchre for instance, the engraving of which is before the reader, is not without its positive technical merits, but it appeals to the beholder not through them so much as through those qualities that are beyond the reach of technique.

P. F. Connelly, a young sculptor who had been studying and working in Florence for a number of years, and who had gained a good repute through his ideal and portrait busts, came prominently before the American public for the first time at the Centennial Exhibition. He exhibited a much greater number of works than any other American sculptor, and displayed as great a versatility as any. The most important of Connelly's exhibits were the bronze group of Honor Arresting the Triumph of Death, the marble group of St. Martin Dividing His Cloak, the marble statue of Ophelia, and the marble statue of Thetis. The last named was a classic theme, treated with a classic simplicity and grace that won for it very cordial admiration. The Ophelia, and indeed most of Connelly's other performances, represented distinctly modern and romantic ideas with regard to the aims of sculpture. The two groups we have mentioned were far more picturesque than sculpturesque in composition, and even the single figure of Ophelia has little or nothing of what we are accustomed to call

statuesqueness about it, but might have walked out of a gorgeously colored picture and have been crystalized into the snowy whiteness of the marble. The peculiarly picturesque attributes of this statue are strongly recognizable in our engraving, which might readily be taken to represent, not a marble Ophelia, but a figure glowing with all the hues of the painter's palette. The adverse criticism that must be made against this statue is that it does not strongly suggest the madness of Ophelia. Apart from this, however, it is distinguished by a singular sweetness and grace in the expression of the face and in the pose of the figure. This statue was admired during the progress of the Centennial Exhibition even more than was the Thetis, perhaps because it was more in accord with modern sympathies and tastes.

The pathetic group of the Prodigal Son, of which we give an engraving, is in the collection of the Pennsylvania Academy of the Fine Arts, it having been presented to that institution some years ago by Mr. J. Gillingham Fell. This is the most important production of its author, Joseph Mozier, a native of Vermont, who has for a long time been a resident of Rome. Mozier was born August 22, 1812. Until he was about thirty years of age art was only an amusement to him. In 1845, however, he retired from business as a Bond Street merchant, in New York, and went to Rome for the purpose of following the natural bent of his inclinations. Among other things he has sculptured statues of Esther, the Wept of the Wish-ton-Wish, a Peri, Jeptha's Daughter, Pocahontas, Rebecca at the Well, Rizpah, and companion figures of Silence and Truth. These last mentioned were made for the Astor Library. Mozier was a successful business man before he became a sculptor, and since he has devoted himself to art his business talents have apparently stood him in good stead, as he has the reputation of being, in a business way, one of the most successful of the American artists residing in Italy. He is particularly fortunate in having his finest performance owned by an

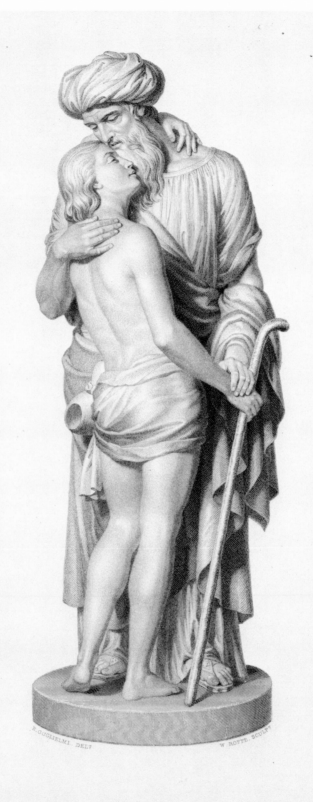

THE PRODIGAL SON

FROM THE GROUP BY I. MOZIER

American institution of the high character of the Pennsylvania Academy of the Fine Arts, and the prominent place which has been assigned to his group of The Prodigal Son in the interesting collection of sculptures belonging to the Academy ought to be most flattering to his pride. There is much pure pathos in this composition, which appeals with directness and force to the hearts of those who pause in their rambles through the galleries of the Academy to gaze on it. The benignity and fatherly tenderness of the old man, who remembers nothing except that the lost one has been found, and the utter weariness of the son, and his complete abandonment of himself to his father's mercies, are expressed in a language that all may read, and that requires no explanation or commentary.

CHAPTER VII.

GOULD, SIMMONS, BARTHOLOMEW AND AKERS

SHAKESPEARE makes the Duke Theseus say in way of apology for the play of Pyramus and Thisbe as represented by Bully Bottom—that paragon of all artistic pretenders—and his comrade clowns: "The best in this kind are but shadows; and the worse are no worse, if imagination mend them." A kindly criticism that embodies a fine philosophical idea, for it is a recognition of the genuine qualities of all really earnest artistic effort, as well. as of the necessity for the spectator being in imaginative sympathy with a work of art before he can properly understand and appreciate it. Standing before Gould's statue of the West Wind, for instance, it is essential for a comprehension of the peculiar points of excellence in the work, not only that the very beautiful idea which has been expressed should be clearly defined in the mind, but that the imagination should come to the aid of the understanding. How could the artist cut out of the heart of a block of marble that has been buried for centuries in the everlasting hills, a personification of

> " —a breath of viewless wind
> As very spirit be,"

except by having come thronging back to him the memory of many a

breezy day upon the prairies, where the tall grasses billowed and bowed as the strong, free air currents came gliding down from the heights of the Rocky Mountains, to whirl in a mystic dance over them? And to be in sympathy with such a personification the spectator must be able to bring up before his mind some image like that which inspired the imagination of the sculptor; then, if art is capable of speaking any language to him, this bright-faced and free-hearted American girl, whom an artistic meta-morphosis has caught and turned to marble in the midst of her joyous dance, ceases to represent a mere phantasy and becomes the embodiment of a fine artistic fact. Such a statue as this ought to impress the imagi-nation in the same manner that the West Wind, sweeping and whirling over the grassy prairies would do. And does it not do this? we would ask of any one who saw it at the Centennial Exhibition, and who knows what the West Wind of the prairies is. The statue is so truly original in conception, and the artist has treated his subject with such disregard of many artistic conventions, that our engraving, while it may give a general notion of it, cannot do it full justice. It is a work that must be studied from more than one point of view, if its full meaning is to be thoroughly understood and appreciated, for the motion which is indicated is very peculiar, and, if the statue is regarded as a mere representation, and nothing more, of the human figure, is an unnatural one. Considered in its true light as a personification, however, the motion of the figure is entirely natural, and the license of the sculptor has its ample justification in the results which he has achieved.

The great originality of Gould's West Wind it is worth while to insist on, and to insist on strongly, for attacks have been made on the statue on the ground that it is not original. The work of which it has been asserted to be an imitation, is Canova's well-known Hebe, but no candid critic who is acquainted with both statues can possibly say that

there are such points of resemblance between them as to lay the American sculptor open to the charge of having borrowed anything from the Italian. The only point in which the two works at all resemble each other is in the backward blown skirts, but Gould has treated his draperies as he has treated his figure, in his own fashion, and as the statues in motion, style and execution are in every way dissimilar, the accusation made against the West Wind is a mere absurdity. Gould, indeed, had no occasion to borrow from anybody, much less from a man of the limited imaginative gifts of Canova, and in all the elements of genuine poetry his West Wind is out of all comparison superior to the Hebe. The sculptor, in a letter to the writer of these chapters, said that the idea of this statue flashed upon him in a moment—as all fine and original ideas, it seems to us, must do to an artist, no matter what labor it may cost him to give them palpable shape in marble or on canvas. That it was a labor of love to mould that idea into shape in the yielding clay, and to give it form in the enduring marble, we can well believe. The artist knew that his idea was a fine one, and that it was well worthy of being worked out in the most perfect shape he could give it. The original of this statue was purchased by Hon. Demas Barnes, of Brooklyn, but numerous replicas of it have been executed.

Thomas R. Gould, the sculptor of the West Wind, is a native of Boston, and was born about 1825. Up to the commencement of the Civil War he was a merchant, and art and literature were mere pastimes for the beguilement of his leisure hours. The breaking out of the war interfered so seriously with the business of his house, which was largely engaged in the Southern trade, that he determined to drop mercantile pursuits and to carry out a long-cherished desire by devoting himself to art. He therefore went to Florence, and, although a man of middle age, bent himself seriously to the study of the technique of sculpture.

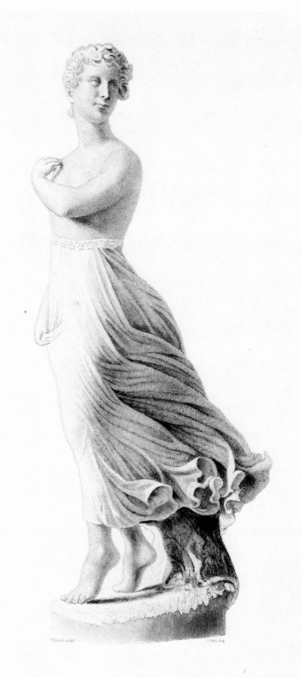

WEST WIND.

One of his earliest performances after becoming a sculptor, was a bust of Junius Brutus Booth. With this great actor Gould was on terms of friendly intimacy, and in his book entitled The Tragedian, he has preserved invaluable reminiscences of Booth's playing in most of his important roles. This little book, in fact, is thoroughly admirable in its way. It relates concerning the actor just the very facts best worth relating, and in reading over Gould's descriptions of the elder Booth's performances, those familiar with the younger Booth's methods, can readily see that he is indebted to his gifted father for many of the finest and most impressive of the "points" which he makes. For instance, any one who has attentively watched Edwin Booth in the character of Cassius in Shakespeare's tragedy of Julius Cæsar, must have noticed how he steps over the body of Cæsar, in the assassination scene, scarcely restraining himself from trampling on it as he does so, his countenance all the while gleaming with an expression of gratified hate and revenge. This detail of stage business seems to have been original with the elder Booth, and it also seems to have made a profound impression on the imagination of Gould, for he alludes to it as one of the most striking features of the actor's personation of Cassius.

Timon is a Shakespearean character that Gould regretfully wishes that the elder Booth had played, and in his statue of Timon standing "upon the beached verge of the salt flood" and letting "sour words go by, and language end," he has apparently attempted to embody the ideal of such a Timon as Booth would have made had he undertaken the part. The artist asserts that the likeness to Booth in this statue is unintentional, but it is so positive that he must, even if unconsciously to himself, have somehow obtained an artistic identification in his mind of the great actor with the misanthrope "sick of this false world," whom the world's greatest poet created for the use of illustrious actors like Junius Brutus Booth.

One of Gould's most imaginative performances is a Ghost of Hamlet's
Father. This is a recently executed relief in marble, and the partial
translucency of the material has been skillfully taken advantage of to pro-
duce a "luminous, gem-like, ghost-like, death-like" face, that appears to
be resolving itself into form out of the marble as out of a thick mist, and
that, with its hollow eyes and the fleecy, cloud-like beard, only half detaching
itself from the surrounding nothingness, is most spiritual in its suggestive-
ness. The sculptor has succeeded in this work in doing what innumerable
artists have altogether failed to do, for "the Majesty of buried Denmark,"
which stalks with so kingly a stride through Shakespeare's tragedy, is not
commonly an impressive figure as represented on the stage or on canvas.

Another Shakespearean work by Gould is a full-length statue of Cleo-
patra—Cleopatra exclaiming as she dies :—

> "Methinks, I hear
> Antony call; I see him rouse himself
> To praise my noble act; I hear him mock
> The luck of Cæsar, which the gods give men
> To excuse their after wrath * * * *
> The stroke of death is as a lover's pinch,
> Which hurts and is desir'd."

The suggestions of this statue are as opposite as may be from those
of Story's celebrated work. Gould has not found it necessary to depart
from the Grecian type which Hawthorne thought tame, but which certainly
is not tame, and his Cleopatra is unmistakably a woman of Grecian lineage.
The artistic value of the work, however, does not depend upon the
realization of any particular type in face and figure, so much as upon
the expressiveness of the pose, which even in its perfect freedom and
abandonment is inspired by a queenly grace and dignity. The fires of

the "great smouldering furnace deep down in the woman's heart," which Hawthorne detected when gazing at Story's Cleopatra, in Gould's statue have burned themselves out, and have left nothing but a mass of cinders and ashes to tell how fiercely they once did burn. This statue is in the possession of Mr. Isaac Fenno, who built for it a special gallery adjoining his magnificent residence in the Boston Highlands.

The statue of The Ascending Spirit in the Forest Hill Cemetery is a work of exceeding grace. The figure really appears to be floating upward, and the artist has been remarkably successful in overcoming the difficulties of his material in carrying out his idea. Two colossal heads, one of Christ, and one of Satan are among the most interesting of Gould's ideal works, while his statues of John Hancock at Lexington, and Governor Andrew at Hingham, Massachusetts, are admirable specimens of portraiture.

The actors are accustomed to say that a character well dressed is half played; with a painter or sculptor a subject well selected accomplishes something more than half the struggle for public approbation which he enters upon when he undertakes a new work. There is no subject an artist can choose that is so absolutely certain of gaining him an admiring audience as a mother and her babe. Whether it is a mere coarse peasant nursing her infant under the shelter of a hay-rick, or a Madonna surrounded by a choir of angels and a Divine Wonder in her arms, or Jochebed fleeing with the child Moses from the insane fury of Pharaoh, and with her soul divided between hope and fear as she pauses for a moment ere she tears him from her own bosom to commit him to that of the Nile, the theme, as old as the first-born of "the thornless garden" makes the strongest appeals to the tenderest of human sympathies. Simmons' statue of Jochebed is a work that no interpretation can give a meaning to if it does not interpret itself at a first glance. The care-worn woman with

her Egyptian coif about her head, with her clinging garments defining her matronly form, and with the innocent babe nestling in her lap, is gazing intently, eagerly and anxiously at the wide river which flows at her feet, and is hesitating to do what she knows must be done. The story tells itself with an all-sufficient completeness, but the merits of the statue do not by any means exhaust themselves with a satisfactory exposition of the subject. The finely executed engraving which we give of this statue shows that it is an exceedingly careful and conscientious piece of work, in which all the details are elaborated with the artist's best skill. The face is full of expression, and the draperies, while broadly massed, as draperies in sculpture always should be, are minutely and elaborately studied in a manner that is suggestive of some of the best antique work. This statue was executed by Simmons for Mr. W. S. Appleton of Boston, and it is one of the earliest of his important works.

Franklin Simmons, like Gould, and indeed a majority of the sculptors that have been mentioned in this work, is a New Englander by birth. When a school-boy, and when going through college he showed a remarkable aptitude for drawing, painting and modelling, and cultivated his talents with such good effect that very shortly after leaving college he decided to start business as a sculptor. His first works were portrait busts, and these were so satisfactory to the subjects and their friends, that the artist was encouraged to follow the example of numerous other young sculptors by going to Washington for the purpose of seeking orders among the public men of the day. He resided in Washington during nearly the whole of the Civil War period, and modelled a considerable number of busts as well as several full-lengths. In 1867 he went to Italy, where he has since resided.

The Jochebed was one of the first noteworthy results achieved after

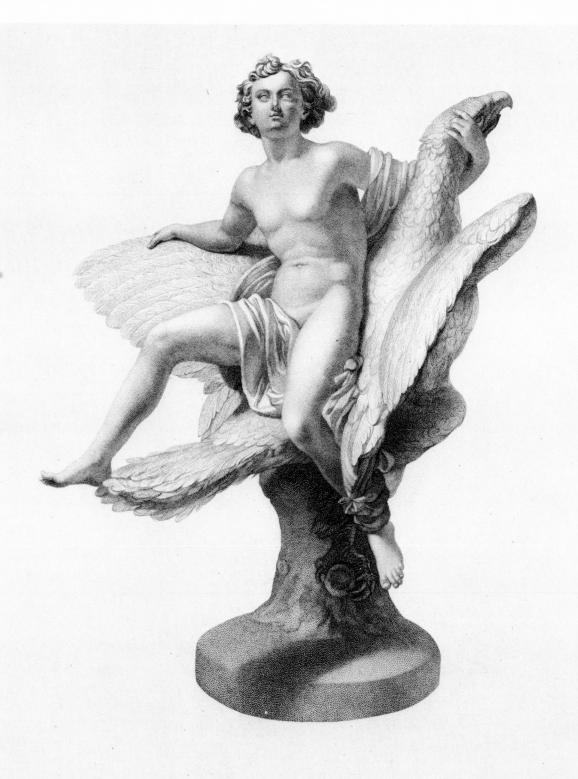

GANYMEDE.

ENGRAVED BY J. H. BAKER, FROM THE GROUP BY E. S. BARTHOLOMEW.

he established himself in Italy. Later he made a marble statue of Roger Williams to be placed in the National Sculpture Gallery at Washington as one of the contributions of the State of Rhode Island. As this work is going through the press it is announced that Simmons has completed a statue of Governor King of Maine, which is also to be placed in the National Sculpture Gallery. If this work is as good as the Roger Williams it is very good indeed, for the statue of the founder of Rhode Island is a performance of very decided merit. It is an ideal statue, as no portraits of Roger Williams are in existence, but the sculptor evidently studied his subject very thoroughly, and succeeded in forming in his own mind a very strongly defined image of a man such as Williams might have been. The statue has been a good deal criticised, chiefly, it has appeared to us, because it does not correspond with ideals which some other people have formed, for even its severest critics have admitted that, apart from all questions of portraiture, it is a work of superior excellence. It is worth while for the American people to prize highly, and to give evidence that they do, a work of the very genuine artistic qualities of Simmons' Roger Williams, as their National Capitol has been made the depository for an infinite number of fearful and wonderful things in the way of pictures and statuary. The National Sculpture Gallery in the old Hall of Representatives, in particular, is filled with mediocrities and worse, in the midst of which such statues as Ward's Putnam, Brown's Greene, Palmer's Livingston and Simmons' Roger Williams assert themselves with an easy superiority, and demonstrate the folly of giving commissions for important national works to beginners and pretenders who debase the title of artist by arrogating it to themselves.

Another very recent performance by Simmons—the most important, in fact, that he has yet executed—is the monument to Roger Williams at Providence, Rhode Island. This was dedicated on October 16, 1877. The

entire work, the pedestal as well as the statues upon it, was designed by
Simmons, and was executed at a cost of $25,000. This monument is
described as consisting "of a broad granite base, with steps rising one
above another, supporting a handsome granite pedestal, and surmounted
by a bronze figure of Roger Williams, seven and a half feet high. On
the steps stands History, a draped figure in bronze, writing the name of
Roger Williams on the pedestal. * * * * The figure of Williams is
ideal, no portrait of him being in existence. He is clad in the historic
costume of the Puritans, showing the entire throat and neck; the coat
collar is tied with a ribbon, the jerkin and other characteristic garments
of the time are there, and on the shoulders rests a Genevan cloak which
lends much dignity to the whole figure, and displays unusual grace in
the flowing folds. The left hand holds a large Bible, pressing it gently
against his breast, while the right is raised as in persuasive discourse.
The face is extremely benignant, combining the Puritan expression with
great spirituality. The forehead is singularly noble. The hair flows down
in mellow lines nearly to the shoulders. The statue of History is classical
in costume, but not in attitude, and the beautiful figure of the Muse forms
a striking contrast to that of the man above, to whom she pays reverence.
This combination of one figure above another is altogether novel, and has
been pronounced bold in the extreme." Simmons was employed for four
years in executing the models for this work, and the bronze castings were
made under his immediate superintendence, at the Munich foundry. The
idea of raising an imposing monument to the founder of Rhode Island
was formulated by the freedmen of the town of Providence more than a
hundred years ago, but circumstances of various kinds prevented its
accomplishment until recently. The city is now indebted to a descendant
of Roger Williams, if not for the monument, at least for the beautiful
Park of which it is a conspicuous ornament. This Park, which was
bequeathed to the city of Providence on the condition that a suitable

monument to Roger Williams would be erected within its boundaries, by Miss Betsey Williams—the descendant above alluded to—is the same estate that Williams received from the Sachem Miantonomah as a special gift in token of friendship and good-will.

Edward Sheffield Bartholomew and Benjamin Akers—more commonly known as Paul Akers—were men who died before they had fulfilled all the bright promises of their youth. They lived long enough to do some notable works, however, and to win the cordial praises of the most discriminating critics on both sides of the Atlantic. Bartholomew and Akers were nearly of an age. Bartholomew was a native of the town of Colchester, Connecticut, and was born in 1822; Akers was born at Saccarappa, in Maine, in 1825. The first mentioned died at Naples in 1858, and the latter at Philadelphia in 1861. Bartholomew was originally a book-binder by trade; afterwards he tried his hand at dentistry. It was a perusal of that most fascinating of autobiographies, the Memoirs of Benvenuto Cellini, that determined him to become an artist. As he was color-blind he determined to devote himself to sculpture rather than to painting. Entering as a student of the National Academy of Design, in New York, he worked diligently there for a time, until being appointed Curator of the Wadsworth Gallery, at Hartford, Connecticut, he was able to pursue his studies under circumstances peculiarly advantageous to him. While he was at the Wadsworth Gallery he made a statue of Flora and some other sculpturesque works of less importance. Encouraged by the hearty praises bestowed upon these, he determined to go to Italy. With the exception of a brief visit he made to America for the purpose of superintending the erection of a monument to Charles Carroll, of Carrollton, he resided in Italy during the balance of his life, and it was in that country that nearly all his important works were produced. After Bartholomew's death the city of Hartford became possessed of his models.

Bartholomew was an artist of very eminent abilities, and had he lived he would undoubtedly have done some great things in sculpture. What he did accomplish entitles his name to a very prominent place in the list of the American sculptors, as all of his best works are distinguished by refinement, grace, and truly poetical sentiment. Bartholomew's best work is probably the Eve Repentant in the collection of the late Joseph Harrison, Jr., of Philadelphia, although the Ganymede—of which we give an engraving —has won for itself admiration almost as great as that which has been bestowed upon the Eve. In the Ganymede, the sculptor has not permitted his classic theme to fetter his free hand with purely classic traditions, and the work is very distinctly a modern one, in spite of its subject. He translated the old legend in his own way, and was doubtless wise in so doing, for he gave the world something original, and an original work of genuine merit is always to be prized above an imitation, no matter how clever the latter may be. Among the works executed by Bartholomew, may be mentioned as the most important, a Blind Homer led by His Daughter; a Calypso; a Sappho; a Shepherd Boy of the Campagna; the Genius of Painting; the Genius of Music; Belisarius; Hagar and Ishmael; Ruth and Naomi; Youth and Old Age; Genevieve, and the Evening Star.

Akers commenced work as a sculptor in Boston in 1849, where he found some one to instruct him in clay modelling and plaster casting. Among his earliest works of consequence were a head of Christ and some portrait busts, which attracted attention by their very intrinsic qualities, and which served to obtain for him commissions. Well-executed busts of Longfellow, Samuel Appleton, Professor Cleveland and other prominent gentlemen, added to his reputation and provided him with the means to go to Europe. He resided for a year in Florence, studying hard all the time, and on his return to America he made a statue of Benjamin in Egypt. When this, his first full-length statue was completed, he modelled

busts for a time in Washington, and then in 1854 he again went to Italy and took up his residence in Rome. It was in Rome that he made the acquaintance of Hawthorne, who was so impressed with his beautiful statue of the Pearl Diver, that he appropriated it, along with Story's Cleopatra, and another of Akers' works—a really noble bust of Milton—for his imaginary sculptor Kenyon, in the romance of The Marble Fawn. Akers' health was very poor during the last years of his life, and he consequently did not accomplish a very great amount of work. What he did do, however, is in a high degree excellent, and his Una and the Lion; Isaiah; Diana and Endymion; St. Elizabeth of Hungary—to mention a few of his finest performances—have won the commendations of those who do not lavish their praises indiscriminately. Akers came back to the United States in 1860, and died in the following year.

CHAPTER VIII.

HARRIET HOSMER AND OTHER FEMALE SCULPTORS

ID it ever occur to any one that such a baby-faced heroine as Guido's portrait of Beatrice Cenci, in the Barberini Palace in Rome, represents, was the most likely person of all others to be the central figure in a tragedy of the peculiar kind that has made the name of Cenci infamous? Miss Hosmer seems to have been impressed with the peculiar characteristics of the face—not merely that indefinable expression which is such a puzzle to all who have gazed on Guido's picture—and she has made an earnest attempt to reproduce it in her recumbent statue of Beatrice asleep on the morning of her execution. The word innocence does not describe the singular qualities of this face, and it is as far removed as possible from the graceful animalism of the Faun of Praxitiles; it is a true baby-face that has something in it other than the innocence of a babe, and that suggests, somehow, a lack of ability to understand or appreciate human responsibilities of the most ordinary kind. It is the sphynx-like character of Guido's portrait, that fascinates while it presents an unanswerable problem in human nature, that has kept alive the memory of Beatrice Cenci, and the altogether disgusting story of crime in which she figures so prominently.

As for Miss Hosmer's statue, it is frank enough in its meanings. The girl has fallen, exhausted in mind and body, into a profound and dreamless sleep, and is absolutely unconscious of the swift passing moments that are bringing her nearer and nearer her doom. There is an unconscious and unstudied grace in the very expressive attitude into which her figure has fallen, with a prayer half said upon her lips and her limp hand unclasping itself from the beads of the rosary, which, ere sleep overwhelmed her with a happy oblivion, she had been telling over with the fervor of utter despair. That Guido's picture was the inspiration for the statue is evident, and the sculptress is to be credited with a most sympathetic interpretation of her original. This interesting work, which, with the exception of her Zenobia, is the most celebrated of the sculptures executed by Miss Hosmer, is in the public library at St. Louis.

Harriet Hosmer, the most famous of American female sculptors, was born at Watertown, Massachusetts, in 1830. Her father was a physician, and she was encouraged by him to follow her natural inclination for outdoor exercise and athletic sports. The death of her mother when she was quite a child threw her greatly on her own resources, and under the peculiar system pursued with regard to her by her father, who was anxious to counteract a tendency to consumption, she speedily developed into a good deal of a Tom-boy, and was more expert at hunting bird's-nests, riding horses, and indeed all manner of boyish pastimes and mischiefs than she was at needle-work and the usual girlish exercises. When quite a child she was a taxidermist of no little skill, and prepared a number of specimens of her own shooting, and at the early age of eight years she showed such a strong predisposition for artistic pursuits as to induce her friends to believe that it would be worth while to cultivate her talents. Miss Hosmer's first serious artistic essays were as a painter. She began this practice when about sixteen years of age, but conceiving that sculpture

was a higher form of art she undertook to learn modelling, and was so successful in making a statuette from a figure in an engraving which took her fancy, that she was persuaded to believe her genius had at last found its proper field of employment. She next attempted a number of ideal busts and portraits of her intimate friends, and having gotten her hand in a measure trained to the proper wielding of a sculptor's tools, she made an essay in marble by copying in reduced size a colossal bust of Napoleon by Canova. At the time she was making these tentative efforts in the art of sculpture, she was also going through the process of being "finished" at the celebrated Female Seminary kept by Mrs. Sedgwick at Lenox, Massachusetts. The attendance at this Seminary had a potent influence on her destiny in more ways than one. To her able and amiable preceptress she was indebted for influences which moulded her rather wayward character in such a manner that from a hoydenish girl who would acknowledge no restraints, she speedily developed into a self-poised woman with all her faculties in training, and with her character formed in such a manner that she was prepared to follow her chosen career with steadfastness as well as energy and perseverance. To a friendship which was formed while at Mrs. Sedgwick's school, Miss Hosmer owed the most active and sympathetic encouragements which surrounded her in the novitiate stages of her artistic career. Her intimate among her school-mates was a Miss Crowe, the daughter of a prominent citizen of St. Louis. On leaving school she went home with this young lady, and what at the outset promised to be nothing more than a mere friendly sojourn with the family of a school-mate, proved to be the turning-point of her career. Mr. Crowe, the father of her friend, if at first he was attracted to Miss Hosmer by her originality and her eccentricities, very soon became satisfied that his daughter had brought beneath his roof a genius, and a very rare one, and a liking for the very independent and rather odd young lady speedily developed into a cordial admiration. The admiration of Mr.

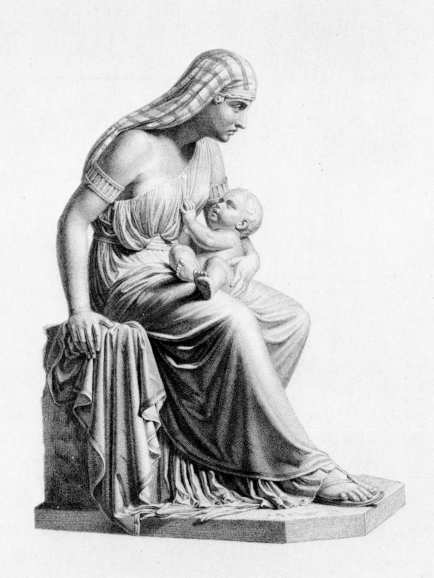

JOCHEBED.

Crowe, however, took an eminently practical turn, and he made it both a duty and a pleasure to encourage and stimulate Miss Hosmer to cultivate her great talents to the utmost.

For a time, however, Miss Hosmer's Bohemian disposition got the better of her desire to win for herself a great name as an artist. She had not been long enough released from the restraint of Mrs. Sedgwick's school to find it an easy matter to settle down to hard work, without first gratifying the roving impulses which were strongly moving within her. She, therefore, started off without an escort for the purpose of seeing for herself some of the wonders of what in those days was called the Great West, and penetrated into the wilderness as far as the Falls of St. Antony in Minnesota. With the savages residing in the vicinity of the Falls Miss Hosmer managed to get upon terms of friendly intimacy, and her residence among them was one of the most pleasurable episodes in her career. All this sort of thing was not by any means bad preparation for the drudgery in the modelling room and the dissecting room, which it was essential should be gone through with before she could produce anything in the way of sculptures that would be entitled to praise from other than warm personal friends.

Having satisfied her adventuresome longings by her trip to the Falls of St. Antony, Miss Hosmer returned to St. Louis, and went to work with a right good will to give justification for the high expectations which her friend Mr. Crowe had formed with regard to her. Under the direction of Dr. McDowell she studied anatomy, and was one of the most regular attendants in his dissecting room. She also practiced constantly at modelling in clay, and when she had obtained some proficiency in the production of forms she essayed putting her modellings into marble. A bust in marble of Dr. McDowell was one of the first of the performances

which she deemed of sufficient merit to go out of her own possession. This was presented to Mr. Crowe. Other portrait busts were followed by a Hesper, a work of truly ideal beauty which excited the admiration of other than partial critics.

By this time Miss Hosmer had exhausted such facilities for thorough artistic instructions as America afforded, and by the advice of her best friends she decided to go to Rome. With a daguerreotype of her Hesper, as a specimen of her abilities, in her possession, she sailed for Europe, in company with her father, in 1852. On arriving at Rome she obtained an introduction to the English sculptor Gibson, and that excellent artist, after looking at the daguerreotype of the Hesper, consented at once to admit her to his studio as a pupil. Miss Hosmer studied and worked under Gibson's direction until his death.

The statue of Zenobia, which is, perhaps, taking it all in all, Miss Hosmer's highest artistic achievement, represents the captive Queen of Palmyra, walking with stately and royal tread in the triumphal procession of her Roman conqueror. The figure is full of dignity and queenly grace, with a fine expression of sorrow and disdain on the face, and it represents the ripe results of a rare native genius, cultivated and brought to perfection under the training of a master who was himself an artist of very superior abilities and very superior attainments, but who fettered himself with theories about the objects and aims of sculpture which condemned him to be an imitator rather than a creator.

The Zenobia was sculptured some time after the Beatrice Cenci, and it confirmed the very favorable impressions which that work made. It was the Beatrice Cenci which first made Miss Hosmer's name known to the English public, and which introduced her to all of her countrymen

except the few friends who had appreciated her talents and encouraged their exercise. The Beatrice Cenci was first exhibited in the Royal Academy in London, and it was afterwards shown in New York and other American cities, previous to being placed in the Public Library at St. Louis. On both sides of the Atlantic it excited admiration, and it is now regarded as one of the chief art treasures of the city where Miss Hosmer first studied art, and where she made her first serious essays as a sculptor. The public Library of St. Louis is also the depository of another important work by her. This is the Œnone mourning over her desertion by Paris—the first full-length statue modelled by the artist after she commenced work in Rome under the direction of Gibson. The Œnone was purchased from Miss Hosmer by her friend and helper, Mr. Crowe, and by that gentleman was presented to the institution which now owns it. At a later period Miss Hosmer made, on a commission from the State of Missouri, a full-length statue of Hon. Thomas H. Benton. Among the other important works by this artist may be mentioned a charming figure of Puck; busts of Daphne and Medusa, which were executed for Samuel Appleton, of Boston; a bust of Mrs. Cass; a statue of a Sleeping Faun; and a monumental statue, in memory of a beautiful French girl.

Emma Stebbins, a native of New York, like Miss Hosmer, has long had her residence in Rome, whither she went some years ago, when, throwing aside her palette, she decided to abandon painting for sculpture. Miss Stebbins originally, we believe, devoted herself to the practice of art merely for the sake of the amusement which it afforded her. With her friends for models, she painted portraits and figure studies, and improved her style by occasionally making a careful copy of a good picture. Her success as an amateur was such that she finally determined to become a professional artist, and, although up to the time of making this decision she had worked chiefly as a painter, sculpture offered such particular

attractions that she took it up in preference to painting. Her first important work after going to Rome was a statuette of Joseph. This elicited warm commendation from good judges, and it was speedily followed by other and more elaborate performances, the chief of which is the fountain statue executed for Central Park, New York, and now one of the artistic adornments of that noble pleasure ground. This statue is called the Angel of the Waters, and represents the heavenly visitor who periodically visited the Pool of Bethesda and conferred upon its waters their healing powers. The idea is a beautiful one, and it has been very beautifully worked out. Other statues in Central Park perhaps surpass this one in particulars of greater or less importance, but there is something in it that appeals forcibly to the imagination of the average man and woman, and it is one of the most admired and popular works that the Park contains. Of Miss Stebbins' other sculpturesque perform-ances there are especially worthy of mention a statue of Horace Mann and one of Columbus. The last named has been very greatly praised.

One of the most important works executed by Margaret Foley, a native of Vermont, is a fountain which, during the progress of the Cen-tennial Exhibition in Philadelphia, was placed in the centre of the Hor-ticultural Hall. This fountain, although on account of not being in the Art Department of the Exhibition, it escaped the notice of most of the art critics and of a good many of the visitors to the Exhibition, was very much better placed for the revelation of its best qualities than almost any of the statuary in the Exhibition. It was in admirable harmony with its graceful surroundings, and it was for that very reason a marked feature of the show in a greater degree than were many other superior works which, in spite of their superiority, were almost lost in the multitudes of pictures and statuary that filled the Memorial Hall and overflowed into its annex. The basin of this fountain is exceedingly elegant in design,

it being formed of broad leaves which thrust out from a central stream and, by overlapping each other, form a receptacle for the water. Upon the ground beneath the basin are two boys and a girl engaged in childish sports. These figures are modelled with much refinement, and they are important elements in a charming composition. Other contributions by Miss Foley to the Centennial Exhibition were a colossal bust of the Prophet Jeremiah and one life-size of Cleopatra. Some of this artist's portrait sculptures have achieved much celebrity, as, for instance, her bust of Hon. Charles Sumner, and her bas-reliefs of the poets Longfellow and Bryant, the artist-poet T. Buchanan Reid and his wife, and William and Mary Howitt.

An even more remarkable sculpture from the hand of a female artist than Miss Foley's fountain which was in the Centennial Exhibition was the Cleopatra of Edmonia Lewis. This was not a beautiful work, but it was a very original and very striking one, and it deserves particular comment, as its ideal was so radically different from those adopted by Story and Gould in their statues of the Egyptian Queen. Story gave his Cleopatra Nubian features, and achieved an artistic if not a historical success by so doing. The Cleopatra of Gould suggests a Greek lineage. Miss Lewis, on the other hand, has followed the coins, medals, and other authentic records in giving her Cleopatra an aquiline nose and a prominent chin of the Roman type, for the Egyptian Queen appears to have had such features rather than such as would more positively suggest her Grecian descent. This Cleopatra, therefore, more nearly resembled the real heroine of history than either of the others, which, however, it should be remembered, laid no claims to being other than purely ideal works. Miss Lewis' Cleopatra, like the figures sculptured by Story and Gould, is seated in a chair; the poison of the asp has done its work, and the Queen is dead. The effects of death are represented with such skill as to be

absolutely repellant—and it is a question whether a statue of the ghastly characteristics of this one does not overstep the bounds of legitimate art. Apart from all questions of taste, however, the striking qualities of the work are undeniable, and it could only have been produced by a sculptor of very genuine endowments.

Edmonia Lewis, the artist of this statue, is partly of Indian and partly of African descent. She was born in the town of Greenbank, near Albany, in New York State, and her first appeal for public recognition as a sculptor was made at the Fair held in Boston, during the progress of the civil war, in aid of the Soldiers' Relief Fund. At that Fair she exhibited a bust of the gallant Colonel Shaw, who was killed on Morris Island while leading his negro regiment to the assault of Fort Wagner. The subject of this work made it an object of interest, while its intrinsic merits won for it cordial commendation, which inquiry into the lineage and circumstances of the artist very naturally did not diminish. The exhibition of this portrait of Colonel Shaw gave Miss Lewis something more than a fair start in the active practice of her profession. The next piece which she produced was more elaborate. The subject was The Freedwoman, who was represented as overcome by a conflict of emotions on receiving the tidings of her liberation, and the pathos of the situation was interpreted in a sympathetic spirit. Since the execution of this statue, Miss Lewis, up to the time of the opening of the Centennial Exhibition, did not keep herself very prominently before the public, and to many of the visitors to that Exhibition, who only knew of her by vague report, the real power of her Cleopatra was a revelation.

Vinnie Reams has been engaged in the practice of sculpture in Washington for several years, and has had the good or ill fortune to figure in the newspapers with considerably more prominence than almost

any other female American artist of the day. Her full-length statue of Lincoln in the old Hall of Representatives in the Capitol, in particular, has been repeatedly referred to, and not in complimentary terms. This work, however, has scarcely received fair treatment at the hands of those who have undertaken to describe it and to discuss its merits. That Congress was not justified in giving a commission for an important statue like this to a very young and very imperfectly trained artist, does not admit of dispute, and that the statue is not at all up to the standard of excellence which ought to be insisted upon for such a collection of the effigies of national heroes as is in process of formation in the Capitol, also does not admit of dispute. There is this, however, to be said about Miss Ream's Lincoln:—although it is a crude and unsatisfactory performance, it has undeniable merits, and no unprejudiced person can look at it without deciding that it was executed by an artist of real talent. Miss Ream has been much more successful in representing in a not ungainly manner the peculiar ungainliness of Lincoln's figure than have most of the male sculptors who have attempted to make full-length portraits of him, and were a sculptor who is a thorough master of the technicalities of his art, to go over her statue and remove the traces of crude workmanship which disfigure it, that which now gives offence in it could easily be made to disappear. As it stands, this is really a better work than some of the statues in the same room that have been executed by artists of greater repute and greater experience than Miss Ream. In addition to this statue Miss Ream has made a number of portrait and ideal busts, and several full-length statues. Selections of what she probably regarded as her best performances were shown at the Centennial Exhibition. These were a bust of a Child, a bust of Senator Morrell, and ideal sculptures entitled The Spirit of the Carnival, The West, and Miriam.

Blanche Nevin, of Philadelphia, studied at the Pennsylvania Academy

of the Fine Arts, and also under J. A. Bailly. The pretty little statue of Cinderella, of which we give a carefully executed engraving on this page is an excellent specimen of her style. This girlish figure, lost in dreams of what might happen, if the crooked ways of Fortune would only straighten themselves out, is gracefully conceived and gracefully executed. It is a representative of a class of sculpturesque works that the best lovers of the beautiful art of sculpture may well wish to see become much more common than they are at present, for they appeal to a larger audience than do the heroic and classic themes which so many artists insist on treating, to their own hurt and to the bewilderment of plain people. Miss Nevin has made a number of busts, and her full-length statue of Eve is a careful study of the nude, the merits of which, at the exhibition of the Pennsylvania Academy of the Fine Arts, when it was first shown to the public, asserted themselves successfully in comparison with many of the works of more experienced artists by which it was surrounded.